BLACKBURN
THROUGH TIME
RAYMOND SMITH

AMBERLEY PUBLISHING

Acknowledgements

Thanks to the following for the use of their photographs:-

Blackburn Museum (pages 29 and 72)
Community History Department of the Blackburn Library
(pages 55, 56, 57, 58 and 68)
William Blackledge (pages 31, 32, 34, 43, 51, 63 and 91)
Lancashire Evening Telegraph (page 17)
Howard Talbot (pages 30 and 59)

ISBN : 1 848685084

Foreword

Some thirty-five years ago I started collecting postcards of Blackburn and now have 2,500. This led me to add other images from all sorts of sources and I eventually teamed up with Jim Halsall to record these electronically. We now have 15,000 images stored on computer. The main difference between the now and then photographs is the large amount of street signs, markings and furniture which does nothing for the eye in the modern world.

We work closely with the Community History Department of the local library and most of these images are available to all. We both give slide shows on Blackburn to local groups and get much enjoyment sharing and talking about these wonderful images of the past. We hope that this small contribution will bring back many memories for the readers who buy this book. We would like to thank Diana Rushton of the Community History Department, Blackburn Museum, Bill Blackledge, Howard Talbot and the *Lancashire Evening Telegraph* for the inclusion of some of their photos and hope that you all find something in the book that relates to you personally.

Raymond B. Smith and Jim Halsall
May 2009

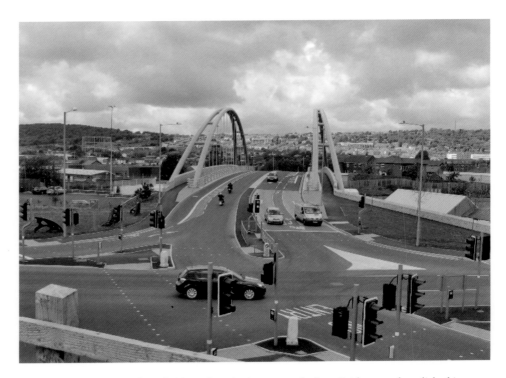

The Freckleton Street railway bridge otherwise known as the Iron Bridge was demolished in 2007 to make way for a new £9 million state of the art bridge to link up with the town's orbital route. A competition was held to name the bridge and the one selected was 'Wainwright' after the well-known walker who was born in the town. It was duly opened in May 2008.

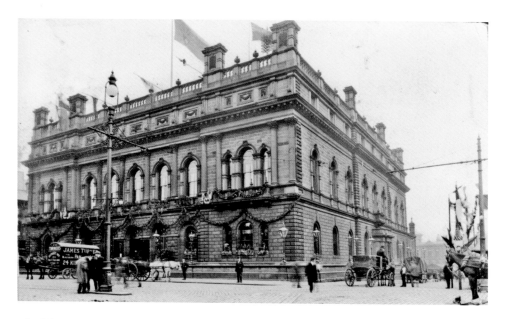

Blackburn Town Hall

Blackburn Town Hall here shown in 1905 decorated with flags flying for some celebration. The Italian styled building was then standing in the large Market Place and covered an area of 2,612sq yds. The foundation stone was laid by Joseph Feilden Esq. on 28 October 1852 and was opened on 30 October 1856 at a cost of £30,000. It contained the mayor's parlour, offices for the Town Clerk, Borough Justices' Clerk, and the Chief Constable plus eighteen prison cells and a large assembly room where balls were held.

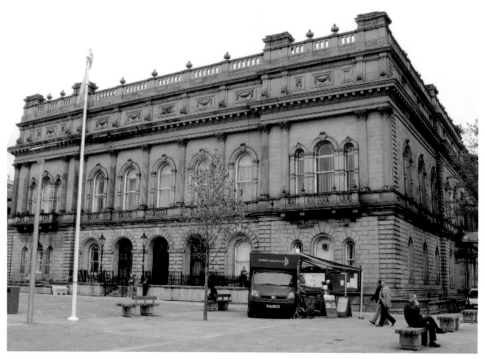

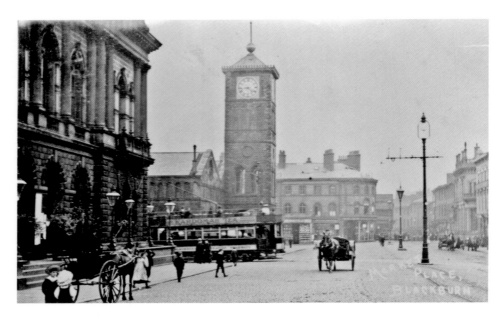

The Market Place

The Market Place in 1903 showing an open-top tram and several types of gas lamps. The Market House with its clock tower was opened on 28 January 1848 and covered an area of 2,253sq yds. The street to the right is King William Street and the corner store in the centre of the picture, known as the Victoria Buildings, was E. H. Booth & Co Ltd, grocers, and tea and coffee merchants with a café.

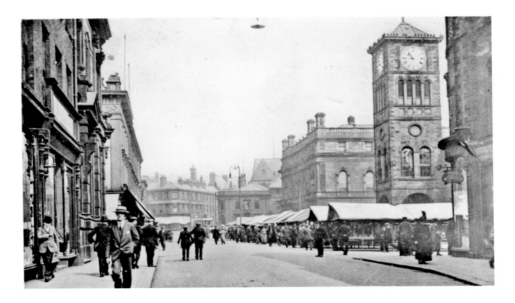

King William Street

King William Street and Market Place looking back towards the town hall on market day, about 1920. The Manchester and County Bank Ltd on the corner before the Peel Buildings is now Marks & Spencers. The bank in the background beyond the town hall was the Manchester and Liverpool District Bank, later demolished, and a new Westminster bank built next to Lewis' Textile museum which is now empty. The twice-weekly market day involved the erection of 220 stalls on the lower part of the Market Place, and eighty-three at the top around the Market House.

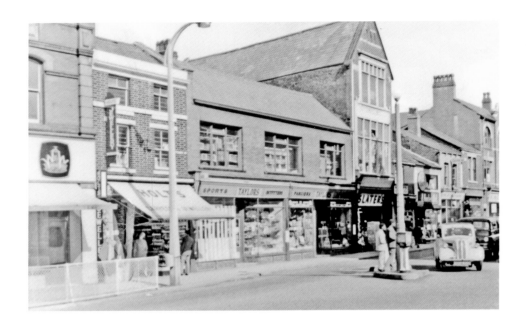

Penny Street

Many people will remember the well-known shops at the bottom of Penny Street prior to their demolition in the 1960s. They were replaced by the market hall which now, some fifty years later is destined for demolition to make way for a new bus station. The shop on the left before Holt's is Weaver to Wearer.

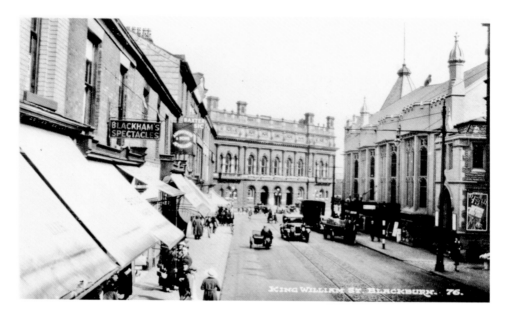

The Cotton Exchange

King William Street looking towards the town hall with the cotton exchange on the right in about 1938. Baxter's bookshop on the left was also a lending library. At the time of this picture it was the majestic cinema, and was later to become the Essoldo and Unit 4. The cotton exchange was opened in April 1865 and held a weekly Wednesday yarn market. When the buying and selling moved to Manchester it became the place to hold public meetings, concerts, bazaars, etc. before being turned into a cinema.

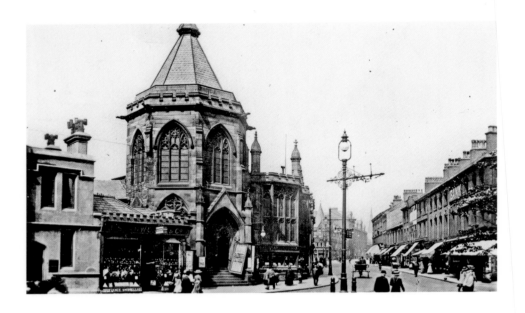

The Exchange Hall

The Exchange Hall and a view up King William Street in 1917. The building on the left was occupied by the Singer Sewing Machine company and was next to Tamworths, the umbrella manufacturers who later moved to Darwen Steet. The small shop to the right of the Majestic Cinema entrance was the only shop outside of Scotland run by Grant's whisky company.

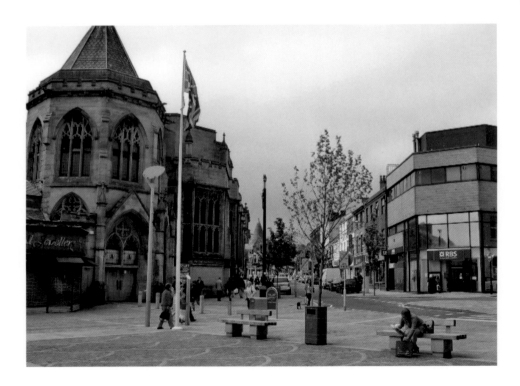

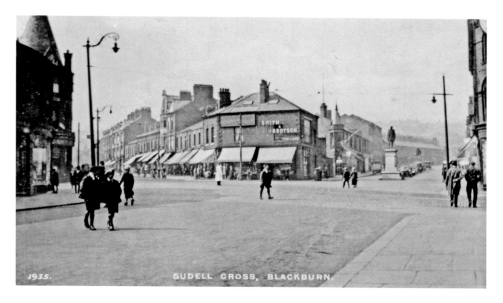

Sudell Cross

Sudell Cross, named after Henry Sudell of Woodfold Hall who was Lord of the Manor before going 'bust'. Looking from Northgate with Preston New Road to the left of the policeman and Limbrick to the right, prior to the Second World War. The statue is of Hornby, which is now situated between BHS and the town hall. In Limbrick, to the left of the statue, can be seen the premises of Walsh's the Ford Motor Dealers – perhaps the cars parked in the centre of the road are all Fords!

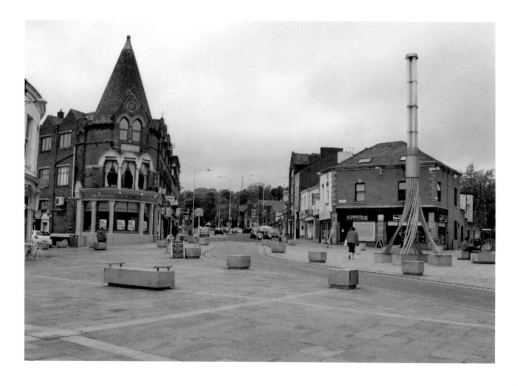

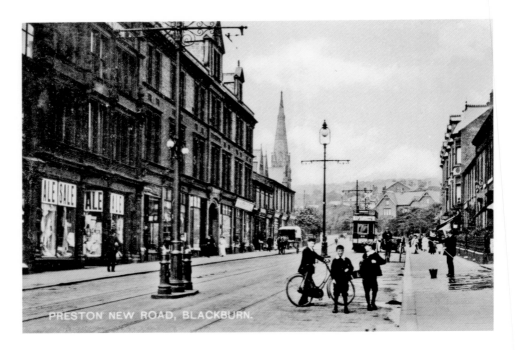

PRESTON NEW ROAD, BLACKBURN.

Preston New Road

The bottom of Preston New Road looking from Sudell Cross in about 1909. The shop with the 'sale' notices was Fowlers drapers and the next building, known as Aspdens, housed a dancing academy which was demolished in 2003 to make way for the Capita building, the one's higher up having been demolished earlier for Barbara Castle Way ring road. The Presbyterian church, which has since been demolished, was dedicated to St George.

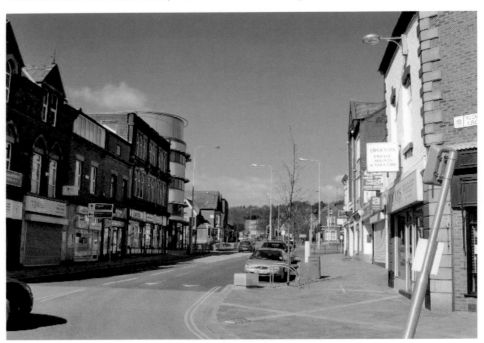

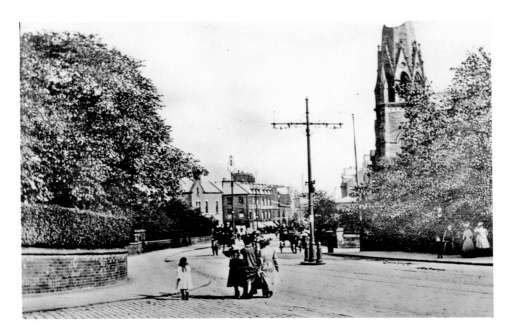

Preston New Road

Preston New Road looking towards town from Shear Bank Road. St George's Presbyterian church, is on the right on the corner of New Park Street and opened in 1869 costing £7,000 with 600 sittings. It was closed and demolished in 1974, having been sold to developers for £90,000. Most of the buildings that can be seen were demolished to make way for the ring road, but the, first building on the left, birthplace of Professor Garstang the famous Egyptologist, is still there on the corner of Strawberry Bank.

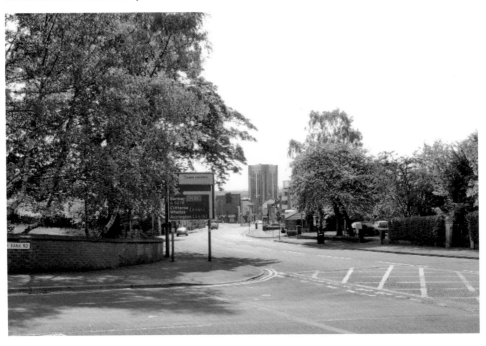

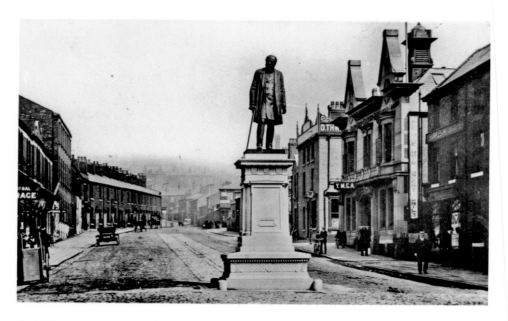

Sir William Henry Hornby

A close up photograph of the statue of Sir William Henry Hornby on Limbrick. He was the town's first mayor in 1851 when Blackburn was granted its Charter of Incorporation by Queen Victoria. He also owned Hornby Mills and was MP for the borough for twelve years. The imposing building to the right was built for the YMCA and opened in 1909. The YMCA moved to a new building in Clarence Street in 1970 and the original building is now the Sir Charles Napier public house.

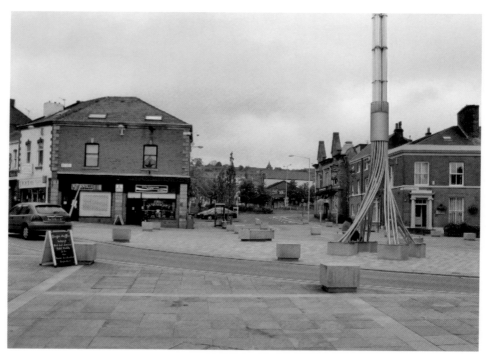

Thunder Alley

Shops on the corner of Northgate and Town Hall Street (previously Thunder Alley) in the 1950s. The shops from the far end are Marsden and Scholes, fish and chip shop: H. Beardwood, boot repairer, A. Orr, hardware shop, Wilkinson Bros, decorators and Miss A. Cohen confectioner and theatre ticketseller.

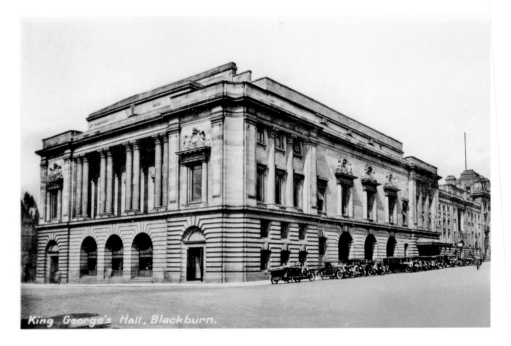

King George's Hall, Blackburn.

King George's Hall

The new Northgate Public Halls, whose foundation stone was laid by King George V in 1913. Messrs Briggs, Wolstenholme & Thomeley and Messrs Stones & Stones of Blackburn and Liverpool designed the halls along with the adjoining Sessions House. It comprised of three halls – lecture hall; assembly hall and King George's hall. Included was a four-manual memorial organ which cost £12,000 being one of the best in the country.

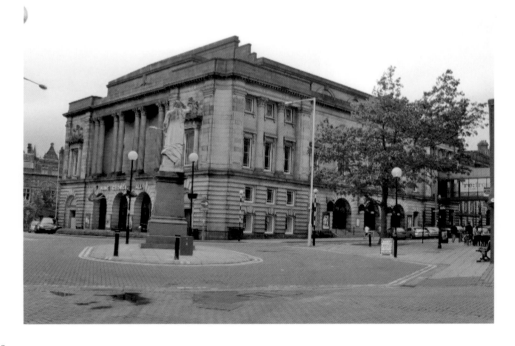

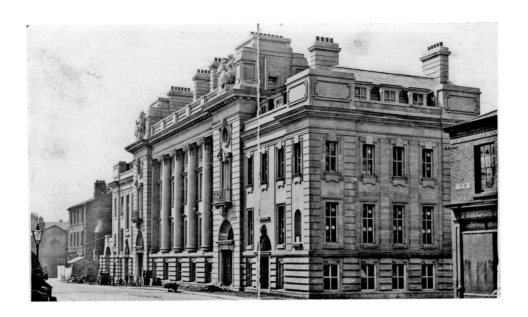

The Police Station

The Police Station and Northgate Sessions House, on the corner of Duke Street. Notice the demolition to provide space for the adjoining new Public Halls, had not yet commenced. The police occupied the ground floor, while the upper floors were occupied by the magistrates and police courts with all the various offices required to carry out the court's work. The contract cost £46,788. As we go to press, new law courts are being built on Barbara Castle Way and the police are at the new Greenbank station, leaving the building to a new use in the future.

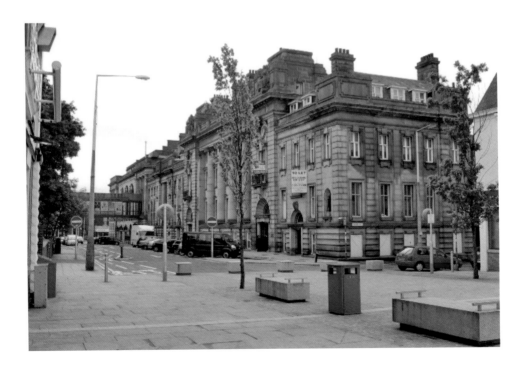

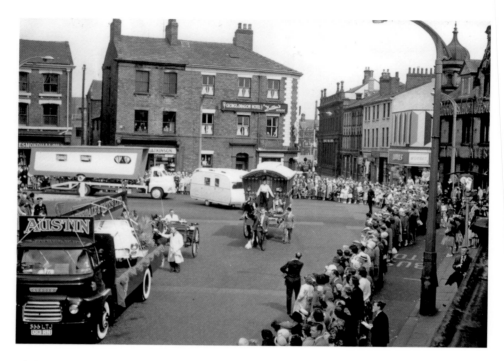

Blakey Moor

Blackburn Carnival parade wending its way through Blakey Moor in the 1960s. The George and Dragon Hotel and the adjoining building were to be demolished for an extension to Marks & Spencer's. The Ribblesdale Hotel at the right of the picture is now the Gladstone. The Gladstone Memorial Statue was unveiled on the Boulevard on 4 November 1899 by Lord Aberdeen, watched by a crowd of 30,000 people. In September 1955 it was moved to a site outside the Technical College and in 1983 was again moved to its present site at the junction of Northgate and New Market Street. The 10ft high white Italian marble statue, standing on a pedestal of red Peterhead granite was sculpted by J. Adams of Acton, London, costing £3,000 which was paid for by public subscription.

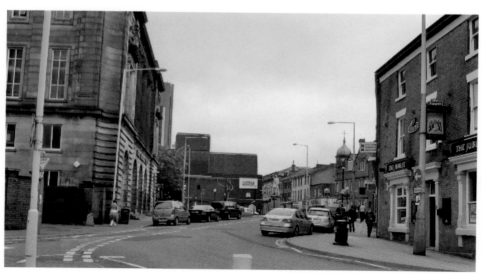

Barton Street

Barton Street from in front of the Technical College in the 1960s with Nab Lane on the right. You can just see the Barton Street Free Church School, built in 1878, which has now been demolished along with the Barton Street Gymnasium. The whole community in this area, which included Warwick Street, Feilden Street, Bond Street and Short Street were dispersed throughout the borough when the whole area was gutted. The Waves leisure centre costing £3.5 million built by Blackburn Borough Council through its inner area programme fund, was officially opened in August 1986. Built by Shepherd Construction Ltd and designed by architects Faulkner Browns it incorporates a Bondi wave machine and a 210ft spiralling flume with a constant temperature of 84 degrees fahrenheit. The flamingo pink water flume was replaced in 1996.

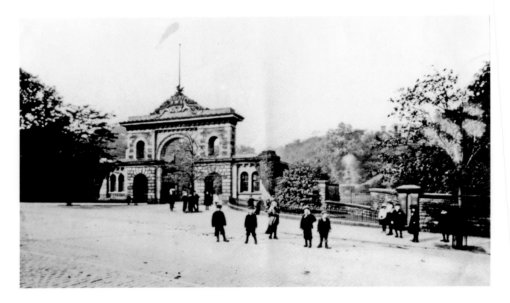

Corporation Park

The main gates of Corporation Park on Preston New Road at the turn of the twentieth century. The park has recently been classed as one of the top 100 parks in the UK. It occupies about fifty acres on the side of Revidge Hill. It was opened on 22 October 1857 during the mayoralty of William Pilkington Esq who presented the four ornamental fountains. The largest one can be seen here in working order but could only operate for short periods of time as it was operated by water pressure from the lakes in the park. The cost of the park up to the day of opening was £14,701 19s 5d.

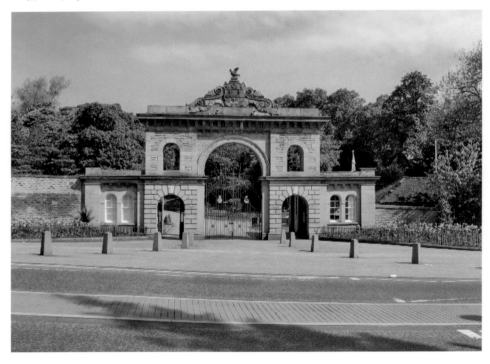

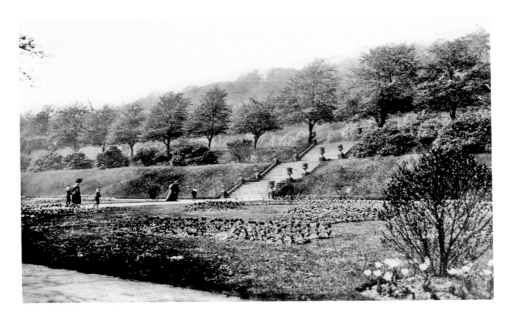

Broad Walk

The flower beds of Corporation Park lie just below the Broad Walk in the centre of the park. They have been altered many times over the years by the various park keepers and during the early part of the twentieth century they were known as the Italian Gardens. The decorative urns on the central flight of steps disappeared many years ago. At one end of the gardens was a shelter which was turned into a café in the '60s with toilet facilities but now is no longer functional. At the other end was a drinking fountain.

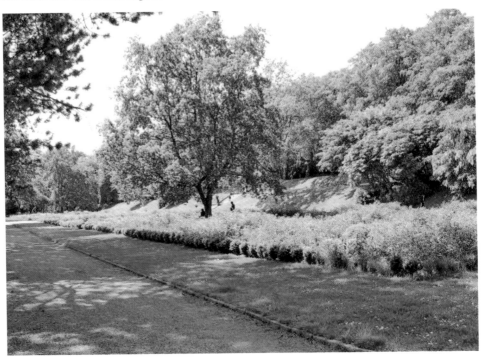

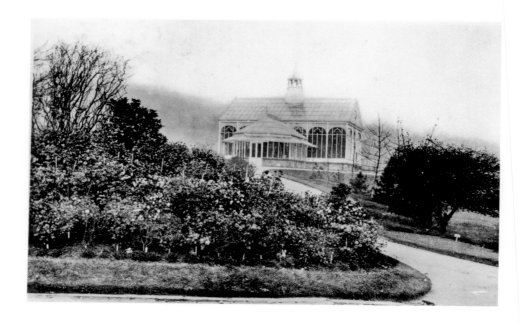

The conservatory

The conservatory as seen from the West Park Road gates in 1909. It was made by W. Richardson & Sons of Darlington and was opened on 16 May 1900. At the same time Messrs Ainsworth & Sons of Northgate made and erected the clock. The heating was installed in 1921. In 1979-81 the whole of the ironwork was renovated and the clock was restored in 1994.

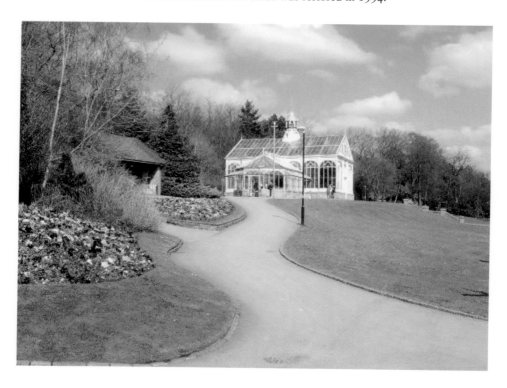

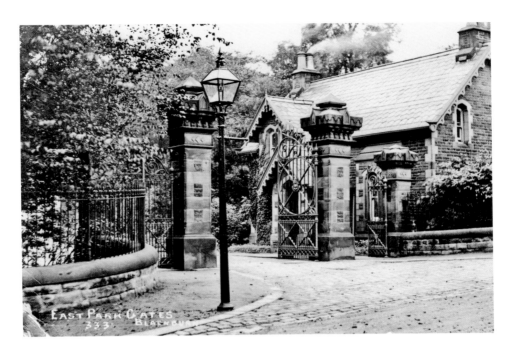

The East Park Road Gates

The East Park Road gates in 1904, photographed by one of Blackburn's most eminent photographers J. W. Shaw. This entrance leads up to the east end of the Broad Walk and provides easy access to the bowling greens. It is at the eastern extremity of the park and Brantfell Road with its sixty steps is to the right of the gateway. Turning immediately left inside the gates the walk down to the lake was known as 'Lovers Walk'. The gates have now been restored with money from the lottery fund.

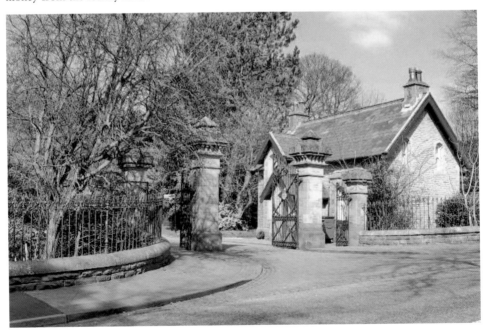

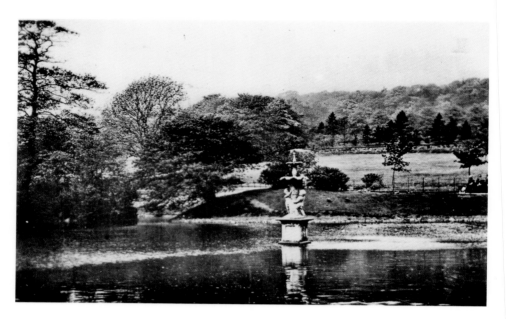

Little Can

The lake and fountain shown is the smaller of two lakes and was known as the 'Little Can' in 1914. From 1772, both these lakes provided water to the town by way of wooden pipes made from hollowed tree trunks leading to stand pipes erected down the hill below Preston New Road. Blackburn Waterworks was established in 1844 and began to supply mains water in 1848 after the laying out of mains pipes had commenced in May 1947. By 1852 twenty-three miles of mains pipes had been laid by Messrs Bramall & Cochrane.

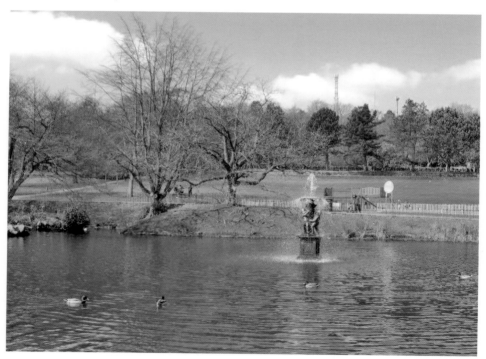

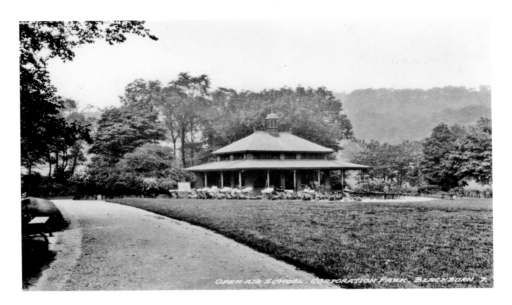

The Tea House

Originally a tea house between the wars it became the Open Air school because of the prevalence of TB. Facing the tea house was the bandstand which was built in 1880 and replaced in 1909 at a cost of £2,000. The last concert from the original building was in 1908 and used a gramaphone system and electrically amplified sound. This was before the days of radio and must have been a novel event because the concert attracted 20,000 people. Rumour had it that it was better to listen to it at Four Lane Ends than in the park itself. It was demolished in 1941 for scrap and the large hole filled in. The Open Air school moved upto Blackamoor and continued for many years. The tea house is now a pre-school facility.

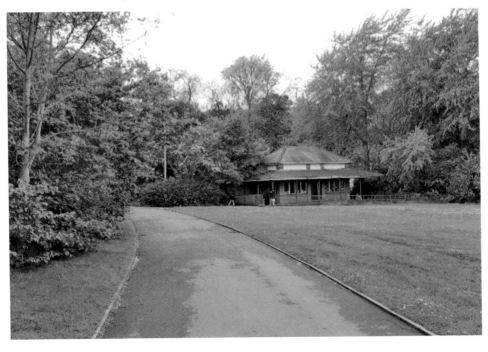

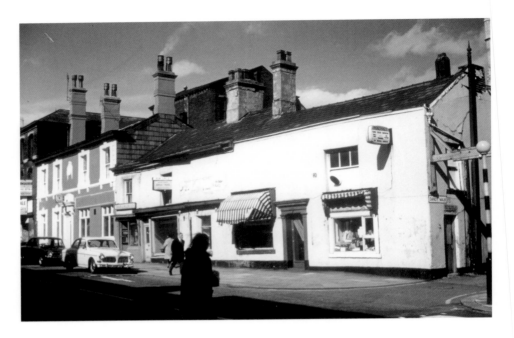

Darwen Street

Darwen Street in the 1950s, showing one of the oldest buildings in Blackburn, the Queen's Head Hotel. The hotel which was adjacent to Dandy Walk, was converted into a shop. To its left is Hargreaves tobacconists' shop and the County Hotel previously known as the Bird in Hand. The shop up for sale was Monks tripe dressers.

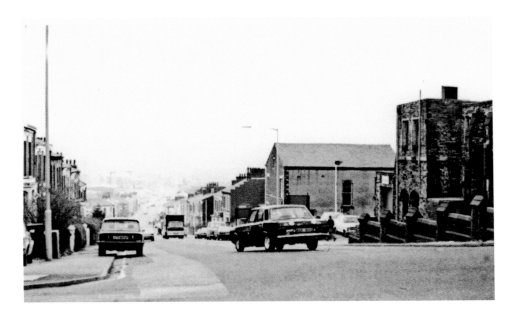

Montague Street

Montague Street has linked Preston New Road and King Street from as early as 1844. The top part of it is known as Branch Road. At the top on the right is the remains of Trinity Methodist Chapel designed by W. S. Varley of Blackburn and built in 1877 at a cost of £13,000. The building is now a garage and health club. Next door is Springside or Springburn House which was the dwelling of Alderman James B. S. Sturdy JP Mayor of Blackburn, 1862-3, who was a solicitor and had been taken in by Dr Barlow as a youngster and became his heir. He laid the corner stone of the Cotton Exchange, was a founder member of The Union Club, and was a member of Blackburn Subscription Bowling Green club when it was at Cicely Hole.

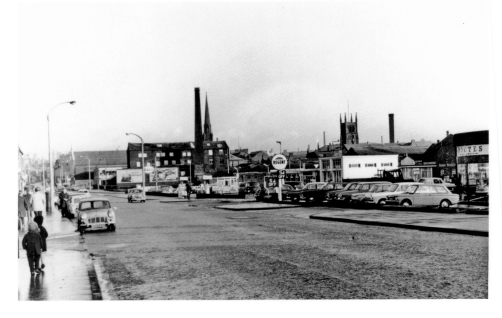

King Street

King Street is a very old thoroughfare of Blackburn. Many of the buildings on the right disappeared many years ago. The church spire behind the chimney belongs to Chapel Street Congregational Chapel and is the only part of the building that remains today. It was a Gothic edifice, opened on 15 June 1874, and built at a cost of £18,000, which superseded an older chapel dating from 1778. The other church is that of St Peter's Church on St Peter's Street erected in 1820-1 at a cost of £13,000. By the late twentieth century the Ecclesiastical Commissioners decided on its demolition because of extensive dry rot. The churchyard is now the victim of a new ring road extension. The Regent Cinema that opened in the 1920s and closed in 1961 can be seen behind the mill.

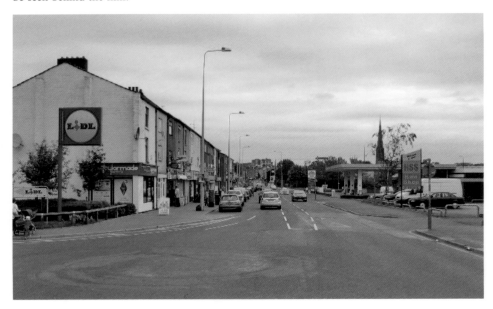

Astley Gate

Astley Gate from the top of King Street in the 1960s prior to the demolition of the buildings on the right. The car park is temporarily awaiting the building of the new town centre and this was to be the ramp leading up to the rooftop car park. The fish and chip shop was Brooks & Hargreaves, next to which was Mrs J. Sims, a confectioner: then Alec Crossland, the cutler with Taylors chiropodist upstairs, and finally Jack R. Hughes, the jeweller. Johnny Forbes the sports outfitters can be seen in the distance and Bank Chambers on the far left still stands.

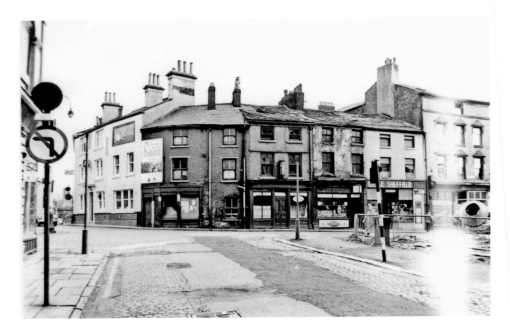

Cardwell Place

Another view of Astley Gate from Cardwell Place. This shows the shops mentioned previously with the addition of the Swan Hotel on the corner and Harrisons tripe dressers next door which had already closed. The Swan had been a Duttons tied house and dated back to at least 1818. Round the corner next to the Swan at No. 1 was and still is the Sun Hotel which dates back to 1796. This area has since been developed.

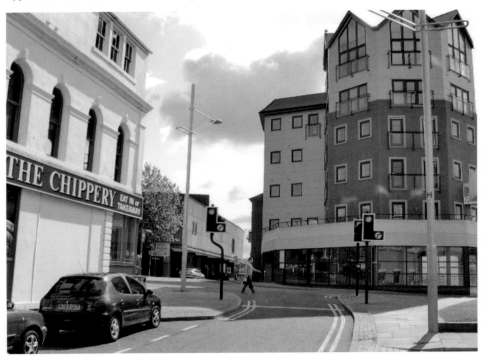

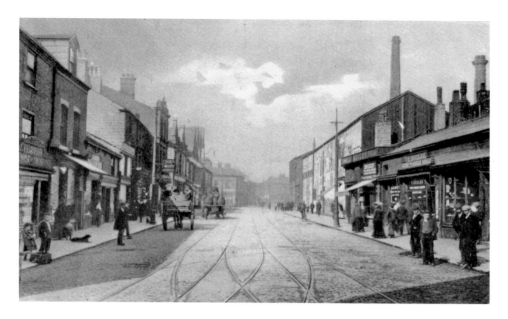

Darwen Street

Darwen Street from the railway bridge in 1906. W. H. Grimshaw chemists is the first left. The building with the high blue roof was Nevilles the fancy goods dealer who put on the best show of goods and toys for Christmas anywhere. The very high building on the right was W. Stones & Sons timber merchants where Edmondsons now stands. After that was Slaters hairdressers, Bromley confectioners, Lang's eating house, Millers hairdressers, Bradley tobacconists and Eccles tripe dressers and fruiterers.

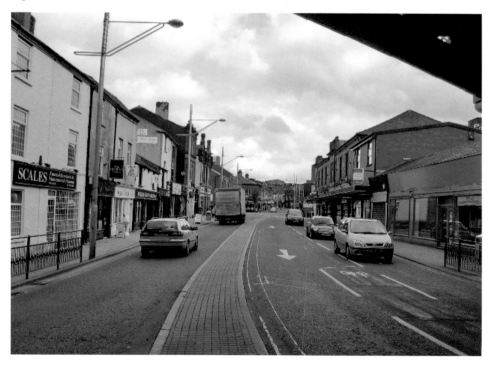

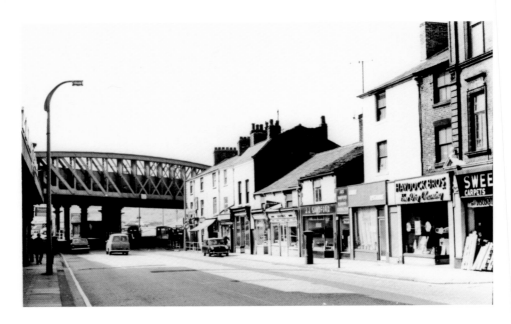

Darwen Street Railway Bridge

Darwen Street railway bridge in the 1960s from outside Edmondsons the funiture store. The bridge, built from parts manufactured by Foster Yates and Thom of Blackburn carried the railway lines for Lancashire and Yorkshire Railway to Manchester, Wigan and Preston which opened on Whit-Monday 1846. Building commenced in January 1884 and was completed in August 1885. The bridge was refurbished in 2000.

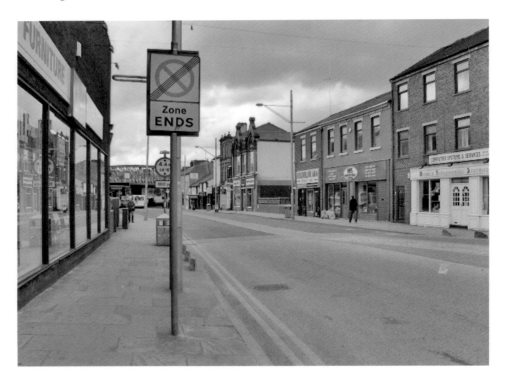

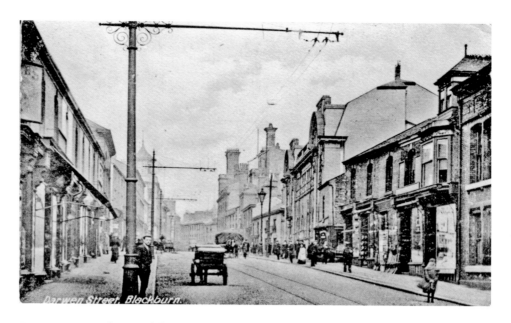

Darwen Street from Jubilee Street

Darwen Street from Jubilee Street in 1910. All the buildings on the right beyond the general post office have been demolished. They include the Old Bull Hotel on the corner of Church Street, Munros wine merchants, the County Hotel, formerly the Bird in Hand, and the Queen's Head Hotel next to Dandy Walk. Most people will remember Stanworths the umbrella makers on the left-hand corner of Mill Lane and Eglens the herbalist further up. The Lancashire and Yorkshire Bank can be seen on the far left with the distinctive pointed roof. It is now occupied by Barclays Bank. On the right, down from the post office, was the Venetian Hall with Eastham's florists and the Merchants Hotel.

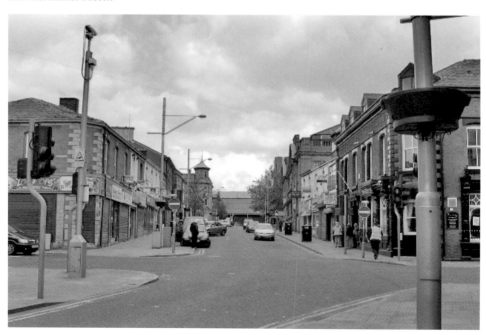

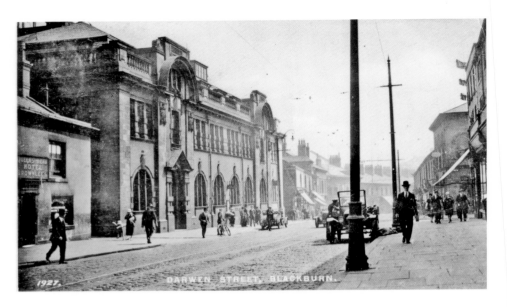

The Post Office, Darwen Street

The general post office on Darwen Street in 1927. This took over from the old post office in Lord Street. It was built in 1906 and the story goes that the plans got mixed up and we got Blackpool's and they got ours. It was designed by His Majesty's Office of Works architect Walter Pott ARIBA and the style was a free treatment of the Renaissance period. It was extended to accommodate the telephone exchange which was previously situated on Astley Gate. Its opening was controversial in so far as the Mayor of Blackburn refused to attend the opening. The Queen's Head Hotel, whose landlord was Miss Margaret Ellen Brownlees from 1803-27, was one of the oldest remaining buildings in Blackburn. It eventually became Normans fruiterers and subsequently was demolished. Its crook lock main beam is preserved in Blackburn Museum. Outside of the post office was the terminal for the Darwen tram service.

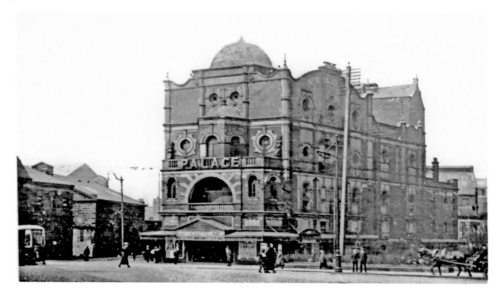

The New Palace Theatre

The new Palace Theatre in Jubilee Street opened on 11 December 1899, but quickly got into financial difficulties and went into liquidation in June 1900. It was bought by the McNaughton Vaudeville Circuit and gave shows for thirty-two years. After periods of being a cinema and bingo hall on and off it was closed in 1984 and demolished in 1989. The old electricity works on the junction of Bridge Street and Jubilee Street have recently become the registry office. The electricity offices behind are occupied by the local borough but all are expected to be pulled down in the not too distant future.

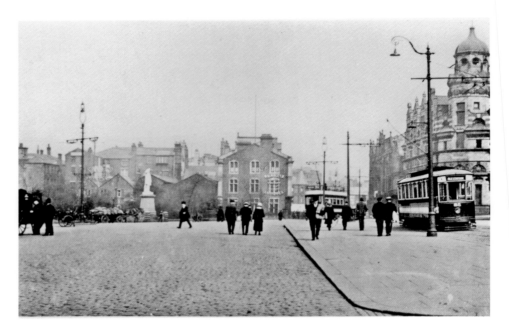

Station Square

Station Square, now known as the Boulevard, shows the *Lancashire Evening Telegraph* headquarters known as the Ritzema building after its owner. The Boulevard was very simply laid out then, but has been continually altered since The Second World War. The building facing was the *Daily Star* offices in 1903 and after occupation by a number of tenants was taken over by Palatine Dairies in the 1950s.

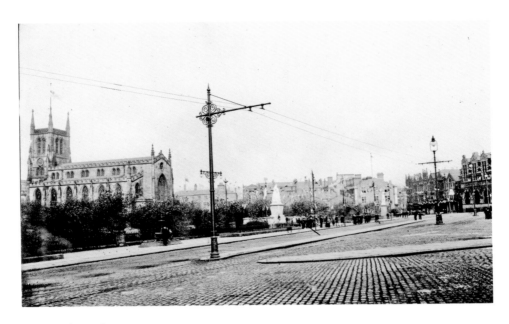

The Boulevard

The Boulevard in about 1900 but showing no trams. However you can see the then Parish Church, Queen Victoria's Statue and Gladstone's Memorial Statue. The 11ft statue of Queen Victoria was unveiled by HRH Princess Louise Duchess of Argyle on 30 September 1905. The cost of £3,000 was met by public subscription. It was sculpted by Mr E. Bertram MacKennel and made from Sicilan marble, surrounded by a Butler Delph stone balustrade.

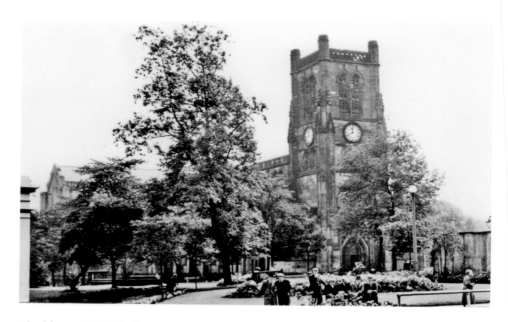

Blackburn Cathedral

The cathedral in 1961. Built as St Mary's parish church between 1820 and 1826 and grade II listed in 1951. The east end can be seen beyond the trees on the left. The Gothic St Mary's is the second church on the site and was designed by John Palmer. The vicar, the Revd T. D. Whitaker, laid the foundation stone on 2 September 1820 and was consecrated by the Bishop of Chester on the 13 September 1826. The church consisted of a nave, north and south aisles, and a beautiful tower in which was a peal of bells. The work cost £36,000. The roof was destroyed by fire in January 1831 and replaced at a cost of £2,500.

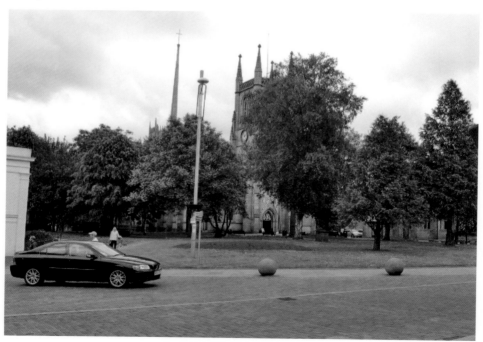

The Organ Gallery

The organ gallery, occupying the west end of the parish church. It cost £3,000 and was presented to the church by Sir William Coddington Bart, MP, and churchwarden, to mark his mayoral year. The organ was made by Aristide Cavaille-Col of Paris and was opened on Thursday 16 December 1875 by W. T. Best, the organ virtuoso from St George's Hall, Liverpool. Restoration work commenced on 30 November 1914 at the cost of £1,000, by T. C. Lewis. In 1964 the organ was dismantled, and was rebuilt in its present position.

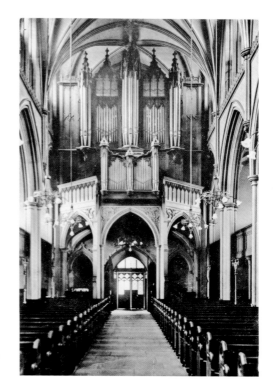

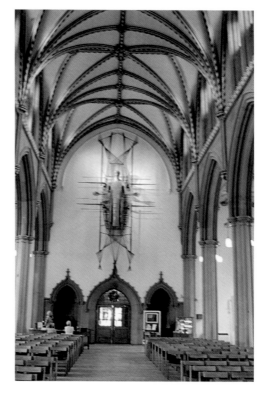

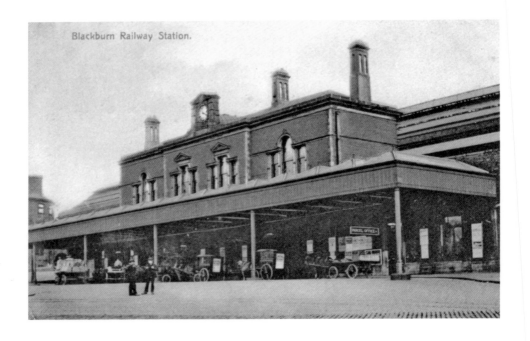

Blackburn Railway Station.

Blackburn Railway Station

Blackburn Railway Station in 1907. This was built and opened in 1886 costing £100,000 it replaced an earlier station. It is the major junction for east Lancashire and sports the Lancashire and Yorkshire Railway Companies' coat of arms on its clock.

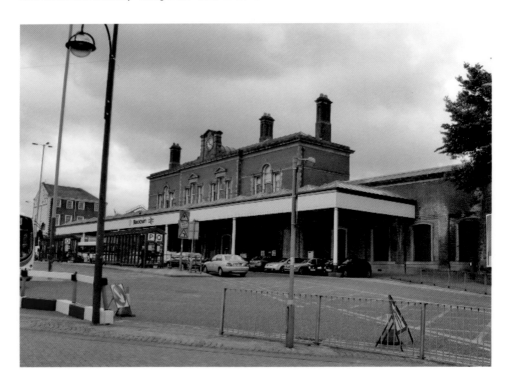

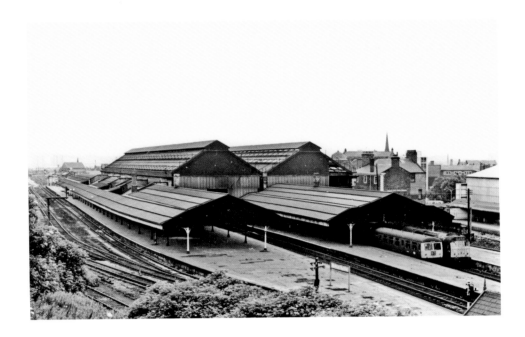

Cicely Bridge

The platforms and canopies of Blackburn railway station from Cicely Bridge in 1971 before it was demolished and modernised in 2000. The Cicely Bridge is immediately in front of a curved 435 yard long tunnel which emerges just short of Daisyfield.

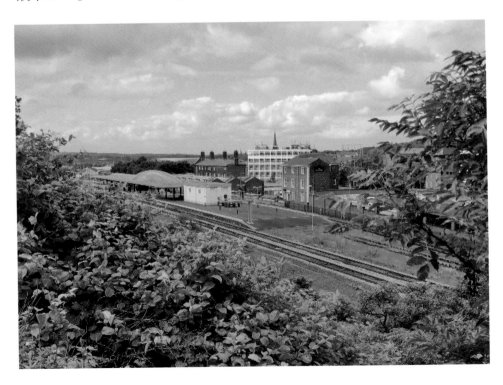

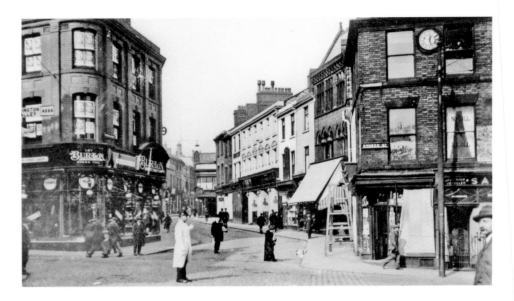

King William Street

King William Street is the main feature of this 1936 postcard looking from Church Street. The building on the left behind the policeman on point duty was formerly the Prince of Wales Hotel and is now another branch of Burtons the Tailors. The building with the clock set in the wall was Sagars the jewellers. King William Street continued further on and after passing another Burtons store, the market hall and town hall, would terminate at Sudell Cross.

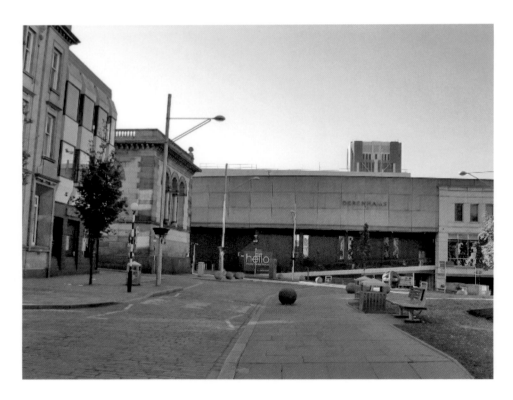

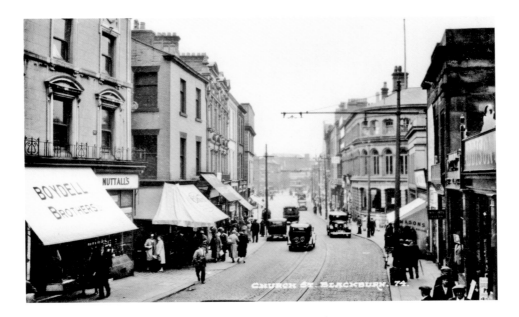

Church Street, 1930s

Church Street in the 1930s looking towards Salford. Notice all the shop blinds out on the left, a common feature in those days. Boydell Bros was a ladies and gents tailors and Nuttalls was the wine merchants, owned by the brewery of that name. On the right-hand side nearest the camera we have Addison & Co. wine and spirit merchants and further down was Masons blanket shop. Continuing down the street, the building jutting out was the Yorkshire Penny Bank, which hosted the junior Conservative club in its upstairs rooms.

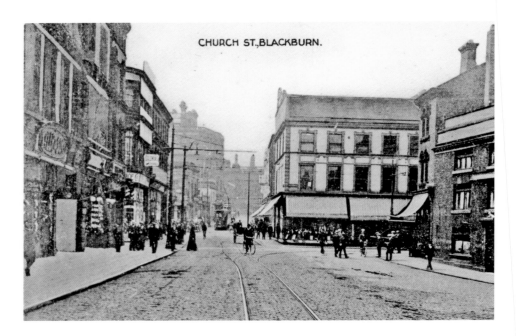

Church Street in around 1910

On the right is the Golden Lion Hotel with Victoria Street adjacent and the Beatty store on the corner. Further up the street can be seen a tramcar heading for the junction with Darwen Street which it will turn into after passing the Old Bull Hotel, which is the large structure on the left at the top of the street. Let us hope that the man on the bicycle in the centre of the scene does not get caught in the tram lines.

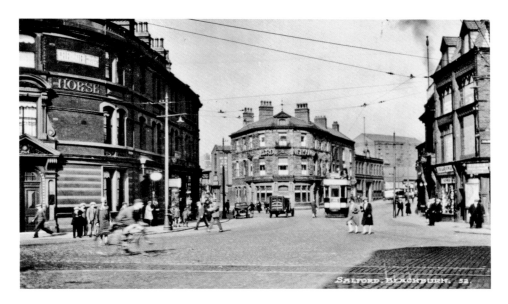

Salford

This mid-1930s view of Salford shows an open top tram at the town terminus of the Intack and Church route. The trams left here between 1932 and 1940 and eventually made life difficult for motorists as they had to wait for the passengers to walk from the pavement and across the road to the waiting tram in the middle of the road. The solution was to build a new terminus round the corner in Eanam in the 1940s. Penny Street was the road to the left going past the Lord Nelson Hotel and onwards to Wilpshire. To the right is Eanam and the road to Intack and Accrington. The semi-circular block of buildings on the right led into Railway Road, and the most remembered shop was and still is the Hake Boat chippy.

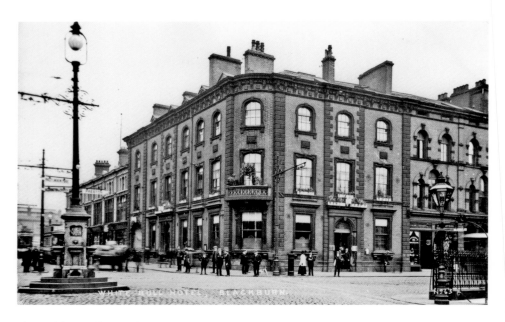

The White Bull Hotel

In this 1905 view we can see the White Bull Hotel on the corner of Railway Road and Church Street along with a close-up of the Salford Fountain. To the right of the picture can be seen part of the gents' underground toilets, with the ladies a little further up Church Street. They served the town well until the town centre developments in the 1960s when they were closed and covered over.

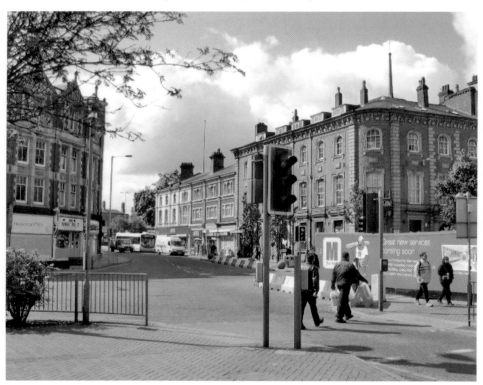

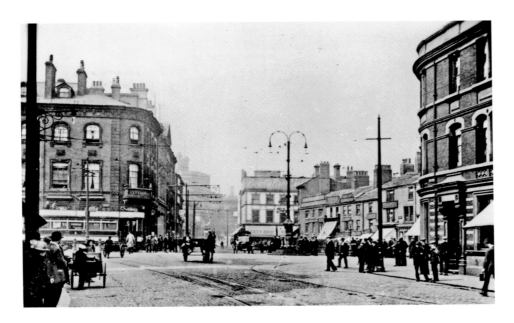

Church Street

An open-topped tramcar exits Railway Road to turn into Church Street, passing the White Bull Hotel as it does so. The building on the right is the Bay Horse Hotel. Once the trams were in Church Street, if going to Preston New Road, they would pass the Golden Lion Inn and turn right past the Beatty Building and into Victoria Steet. Trams to Cherry Tree, Darwen and Queen's Park would carry on up Church Street to the policeman on point duty and into Darwen Street.

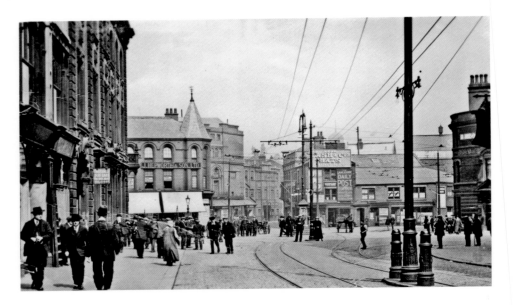

Railway Road

A 1920s view of Railway Road (Station Road) and Salford. Messrs Hepworth & Son, with the white blinds, was to become the offices of the corporation's transport departments. In later years it would be the Woolworth's art-deco style store which has recently been demolished. Notice the very ornate traction poles that carried the electric wires for the trams. In the centre of the picture can just be seen the Salford Fountain which was donated to the town by Miss Thwaites on the 20 September 1884. In 1923, minus the traction pole attached, the fountain was moved to Pleasington playing fields where it is located today.

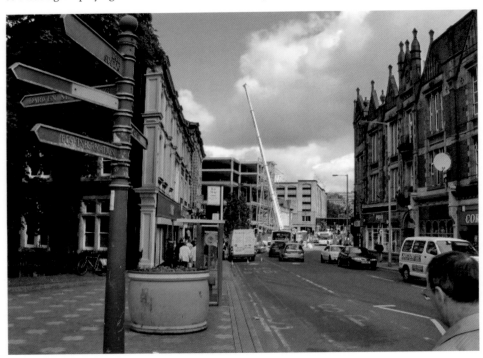

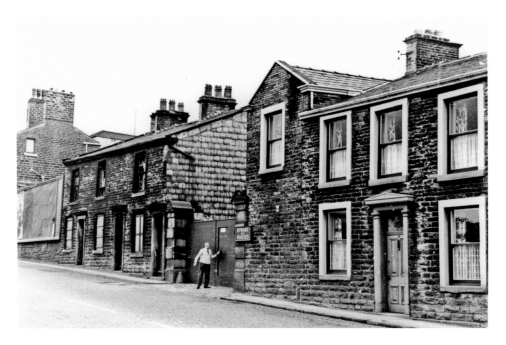

Thwaites' Stables

The gentleman at the door of Thwaites' stables in Eanam 1971. This was the home of the famous shire horses and dray floats, that were a veritable traffic stopper when they emerged for the occasional town centre deliveries. The three houses were later pulled down.

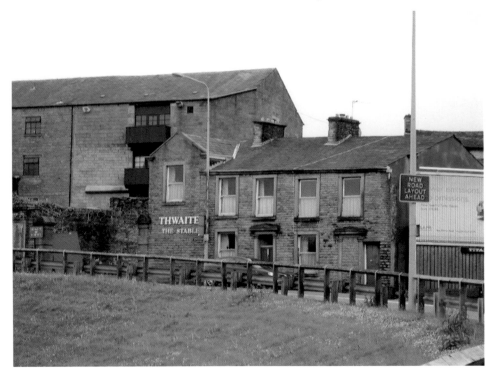

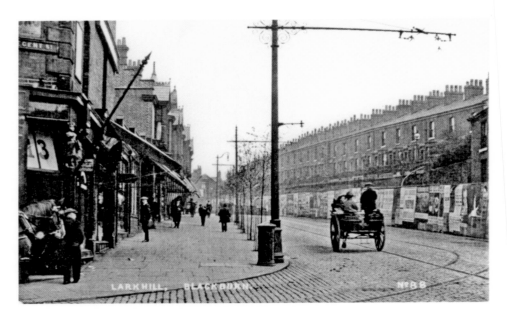

Larkhill

Larkhill and the corner of Regent Street looking out of town in about 1915. In tramway days, when returning to town the Wilpshire trams turned into Regent Street and then into Victoria Street before arriving in Salford for the journey back. The terraced houses on the right festooned with adverts were demolished in the early '60s when the Larkhill flats were built. Remember the horse drawn milk floats like the one in the foreground? They were a common sight between 1900 and 1905.

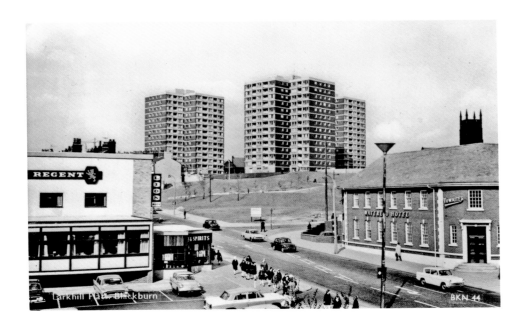

Penny Street

A 1960s view of Penny Street with the Lion brewery-controlled Regent public house on the left and the Thwaites' owned Waterloo opposite. The three blocks of Larkhill flats have now been reduced to one. In the distance is Holy Trinity church, which is now closed. Barbara Castle Way now passes behind the Waterloo and the Regent was demolished many years ago.

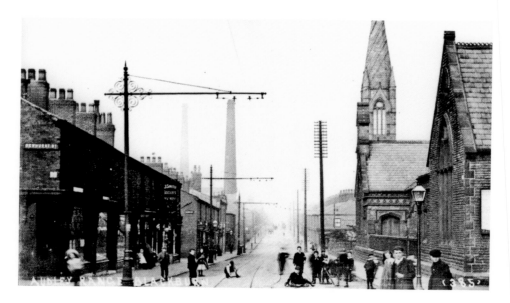

Audley Range

Audley Range in around 1910 with an abundance of children playing in the road. Most of the traffic would have been horse-drawn vehicles and electric tramcars that provided a regular service from the town to the gates of Queen's Park. The route was opened on 4 December 1903. On the left-hand side of the picture we see row after row of typical terraced houses. To the right we see Audley Range Congregational church and school. The church had a lovely ornate steeple that sadly has now been demolished. The tall factory chimney nearest the road belonged to Audley Range mill.

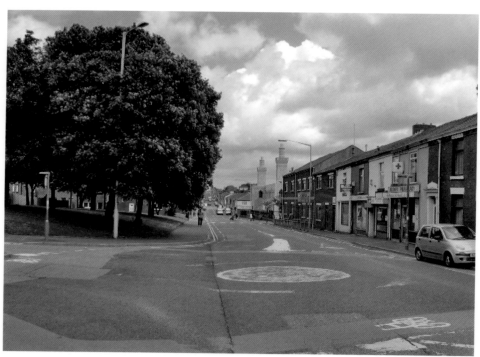

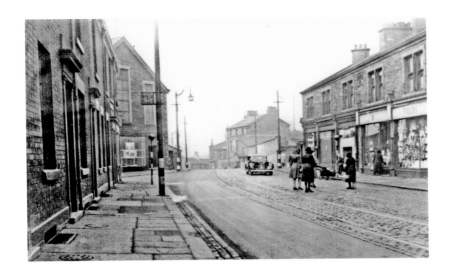

Eanam

A shot during the Second World War of the top of Eanam looking towards the town, one of a series of pictures taken to promote road safety on the wartime roads. On the right can be seen the shop fronts of 'Fields ruby lamp'. The tall building behind the motor car was the Navigation Inn which is now demolished. The buildings on the left are still standing today but the tall one at the end was the Victoria Cinema, which had the distinction of ending its days by collapsing down a disused brewery well.

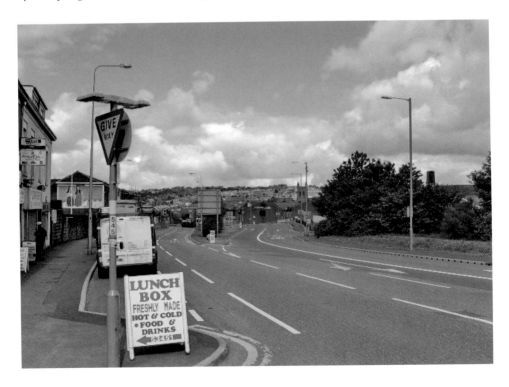

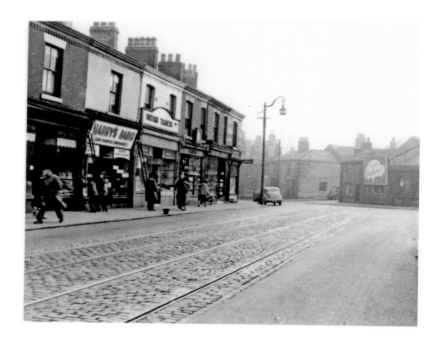

Higher Eanam

A range of shops at Higher Eanam just before its junction with Copy Nook in the 1950s. Starting with Hodgkinsons confectioners, they were: Harry's, radio dealers; British Traders, grocers; J. S. Smith, watchmaker; Grimshaw's, chemists and H. Ormerod, hairdressers.

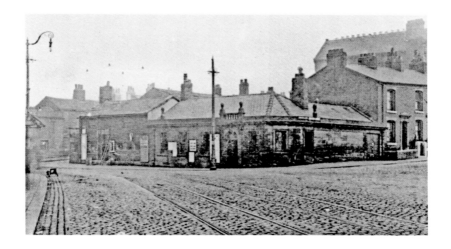

Copy Nook

A 1906 view of Copy Nook showing the police station on the corner. The tall building in the background on the right was known as Shaw's Audley Maltings. The road to the left takes you through Bottomgate and Furthergate on its way to Intack and Accrington. Audley Lane is to the right of the picture. The name Copy Nook is shown as Far Coppy Nook on Gillies' Map of 1822.

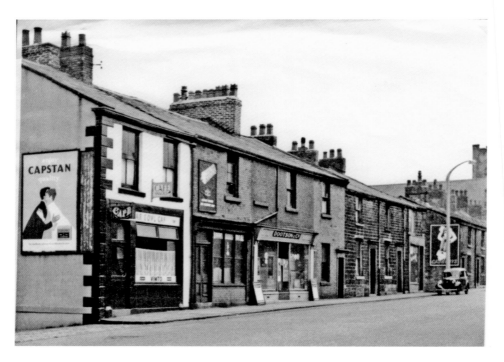

Accrington Road

Accrington Road in the 1950s, with St Jude's Church on the right. The parked car is at the top of Bates Street which led down to Rodgett Street. To the left of the gable end with the cigarette advert could be found the original Printers' Arms public house. All the property to the left of the motor car was demolished to make way for the new route of Burnley Road, and the original Burnley Road was turned into another new road.

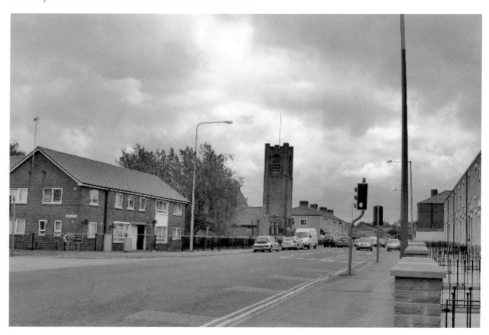

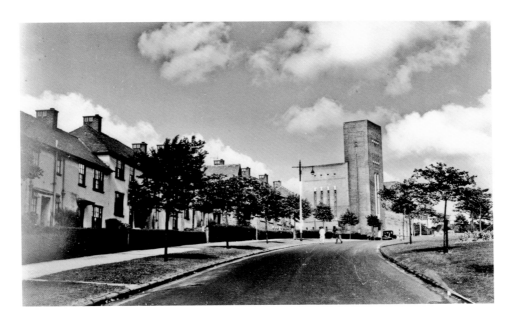

Brownhill Drive

Brownhill Drive, with St Gabriel's Church of England church on the hill. The foundation stone was laid on 5 March 1932 by the Bishop of Blackburn, Dr P. M. Herbert and consecrated by him in 1933. It was designed by F. X. Velarde of Liverpool and cost £20,000. Between 1969 and 1975 some £40,000 of work was necessary on the roof and tower because of water penetration. The large red neon cross was installed on the tower in October 1964.

The Arterial Road, as it was known, went from Yew Tree to Whitebirk. It was constructed between 1924 and 1927 at a cost of £141,000. As part of the work, four bridges were built, including the Brownhill and Harwood Loop Bridge, in reinforced concrete over the London, Midland, and Scottish Railway; Whitebirk Bridge in reinforced concrete over the canal, and a steel girder bridge to carry the railway over the road.

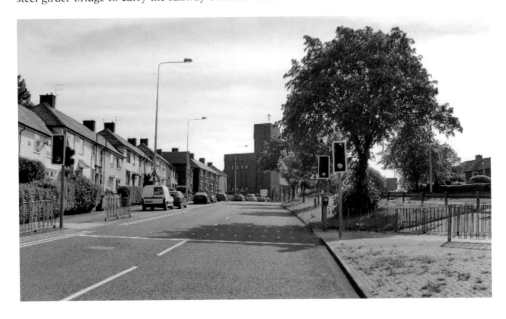

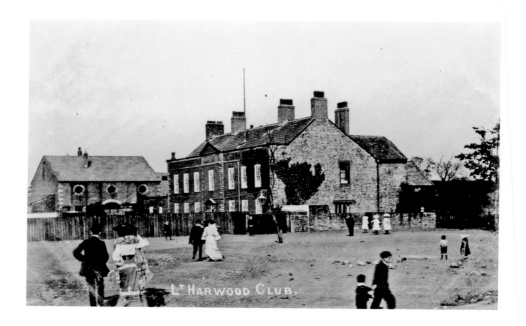

Little Harwood Hall

St Stephen's Conservative club Robinson Street in Little Harwood at the turn of the twentieth century. It was opened on 21 April 1894 by Sir Harry Hornby in Little Harwood Hall, the ancestral home of the Claytons. The neo-classical north front is still as it was and some traces of its Jacobean origin are still present.

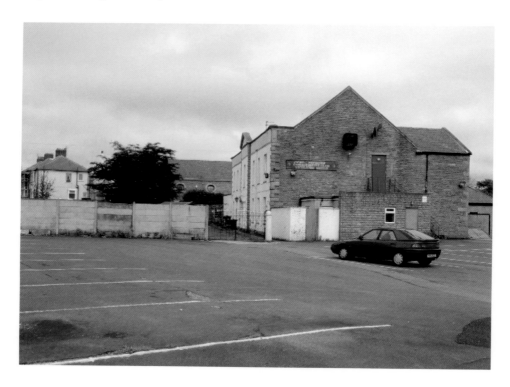

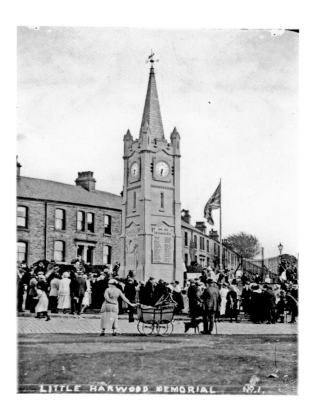

Little Harwood War Memorial
A view of Little Harwood war memorial and clock tower which was unveiled on 11 August 1923 by Major General A. Solly Flood before a crowd of 12,000 and had cost £1,000. This photo was taken shortly after the ceremony. The memorial records some ninety-six names of fallen soldiers from the area. It was designed by local architects L. H. Maxwell and G. G. Dickinson of Bank Chambers, Lord Street West.

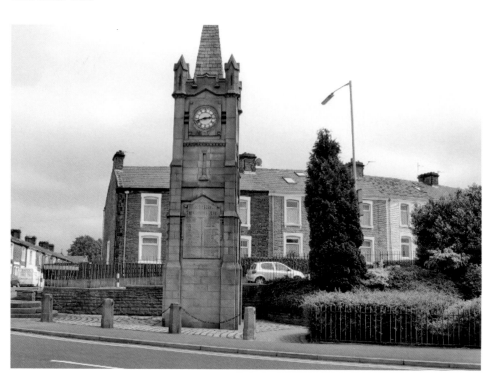

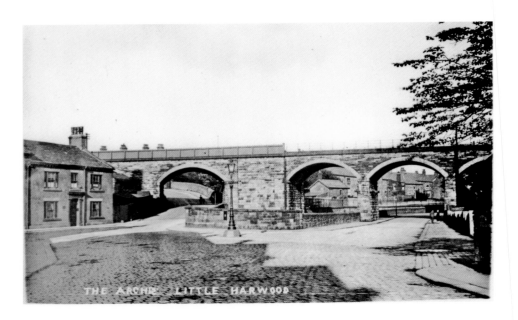

Cob Wall

Cob Wall in the early twentieth century. The Beechtree public house is on the left with the Blakewater river in the centre coming under the Railway Bridge. The pub was owned by Duttons as early as 1888. The viaduct provided access for the Blackburn, Clitheroe and West Yorkshire Railway which was opened in 1850 and the first train arrived in Clitheroe on 20 June 1850. In 1996 a £105,000 facelift for the viaduct was completed.

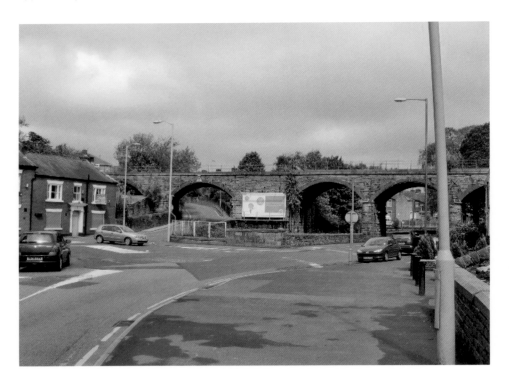

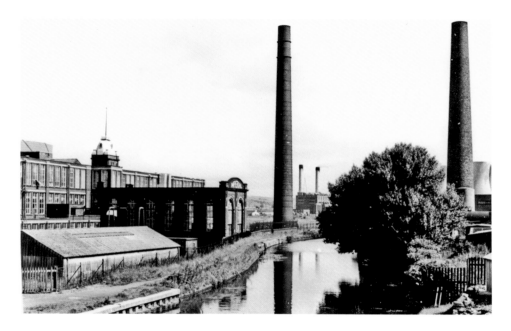

Imperial Mill

Imperial Mill at Gorse Street on the Leeds and Liverpool canal in 1971, also showing the Whitebirk power station and cooling towers in the distance. The mill was owned by the Imperial Ring Mill (Blackburn) Ltd and then from 1939-58 the Lancashire Cotton Corporation Ltd and was Grade II listed in 1974. The power station was opened on 22 October 1921 by Lord Derby and a further extension was completed in 1945 at a cost of £2 million. It closed in 1976 and the cooling towers were demolished in May 1982.

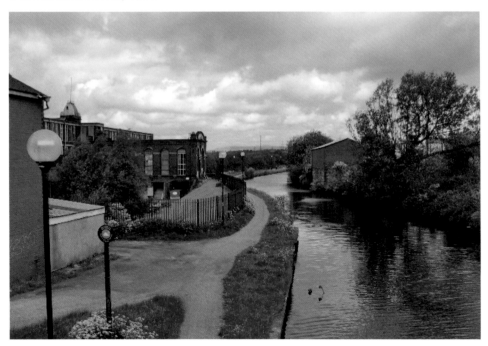

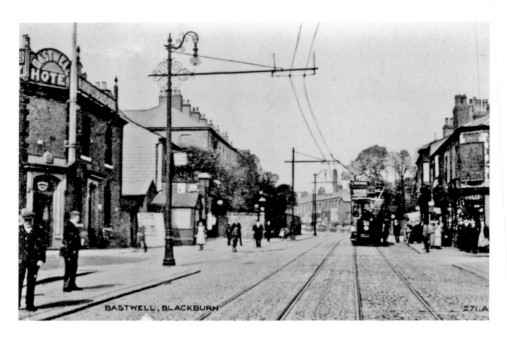

BASTWELL, BLACKBURN 271.A

Bastwell, Whalley New Road

Bastwell, Whalley New Road as seen in 1914. The Bastwell Hotel on the left was tied to the Henry Shaw brewery from the 1870s but became a Thwaites house. The shed structure next door was a borough police box. On Plane Street corner to the right is Fowler's footwear retail outlet which in later years became the post office. The tramcar is returning to the town from Wilpshire and will resume its journey when all the passengers have boarded the car.

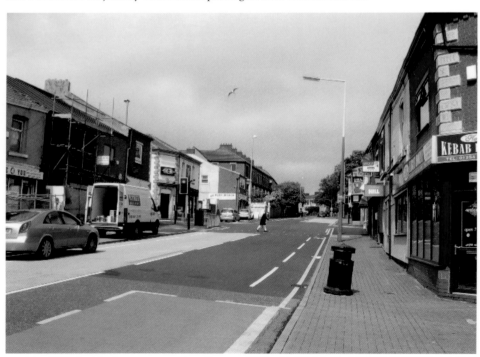

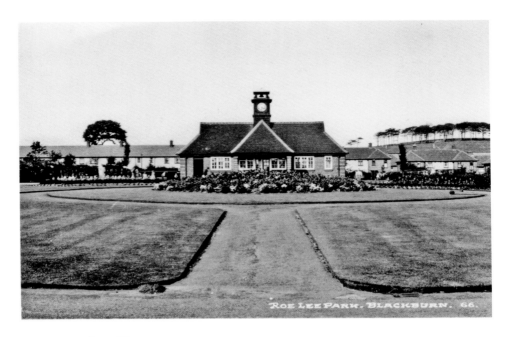

Roe Lee Park Pavilion

Roe Lee Park Pavilion as seen in 1937. The park was opened on the 30 May 1923 by John Duckworth JP and John Eddleston JP of Duckworth & Eddleston cotton manufacturers at Roe Lee Mills. They had given the site to serve a growing population in the Whalley New Road district. It had an area of seventeen acres and contained three bowling greens, five tennis courts, a putting green and children's playground.

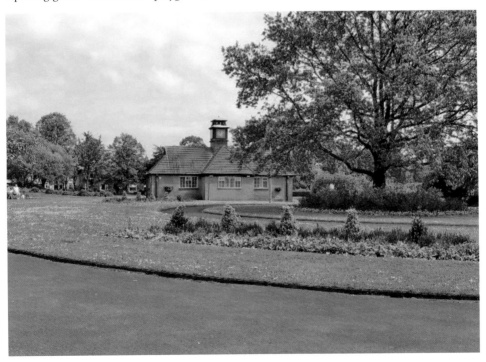

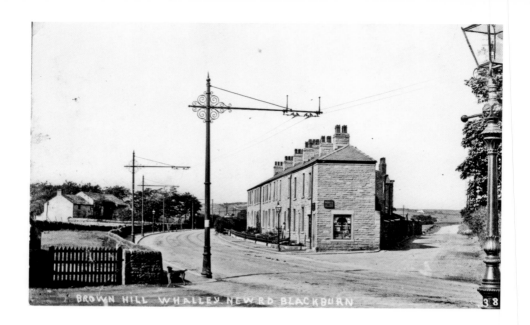

Brownhill Post Office

Brownhill post office on Whalley New Road early in the twentieth century and now. Brownhill Road to the right was totally rural. With so little buildings one wonders how many people used the trams to and from the Wilpshire terminus.

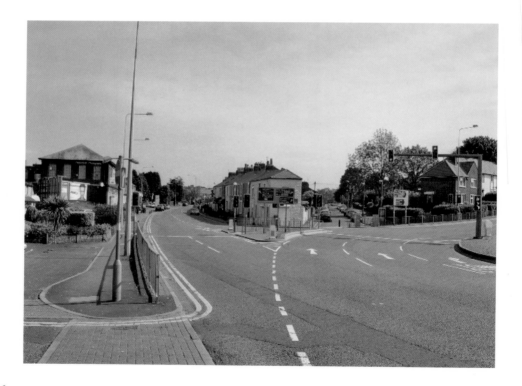

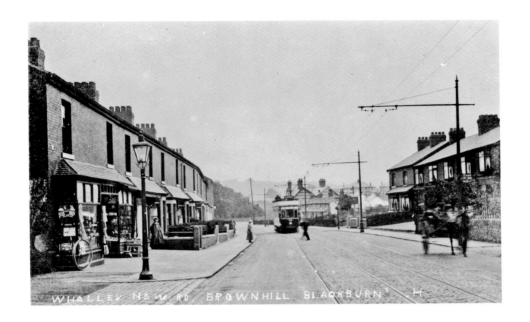

Brownhill Arms Hotel

Another early view of Brownhill looking back to the Brownhill Arms Hotel and the Brownhill Cottages. Neither the Brownhill Cottages or the Co-op had been built in 1903.

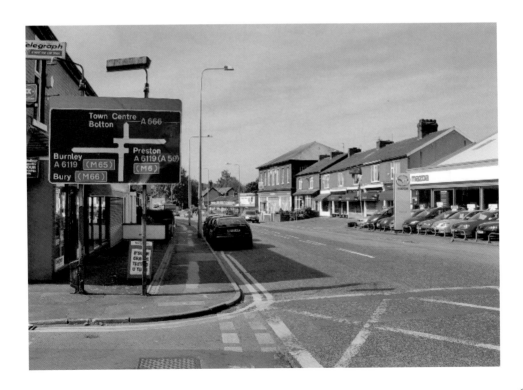

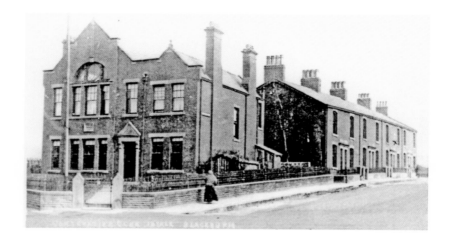

Accrington Road and St Ives Road

The junction of Accrington Road and St Ives Road at Intack, with Intack and Knuzden Conservative Working Men's Club in the foreground. Building work began in 1892 and the cost was quoted as £600. Messrs Sames and Green of Northgate were the architects and the building was opened in April 1893 by Mr R. A. Yerburgh MP in the presence of a large gathering. Mr F. Baines presented Mr Yerburgh with a silver key with which to open the building and after numerous speeches, he obliged. A typical Lancashire lass in clogs and shawl passes the club on her way up St Ives Road.

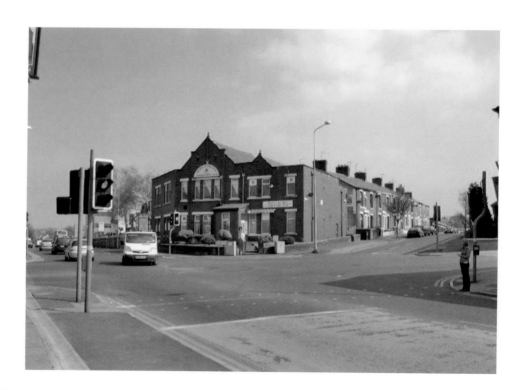

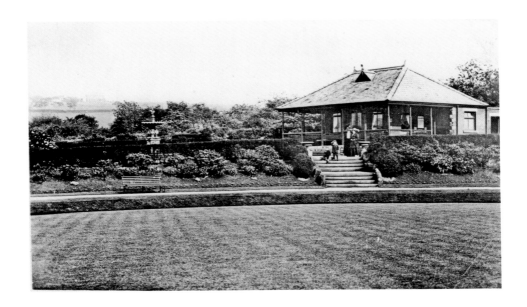

Queen's Park

The round green at Queen's Park, the only one left of four. The thirty-three acre park was laid out by the Borough Engineer and opened on 20 June 1887 having cost about £10,000. A three and a half acre artificial lake was used in the summer by motor boats and rowing boats. In the winter the lake level was dropped and skating took place on the ice. The pavilion is a constant target for vandals.

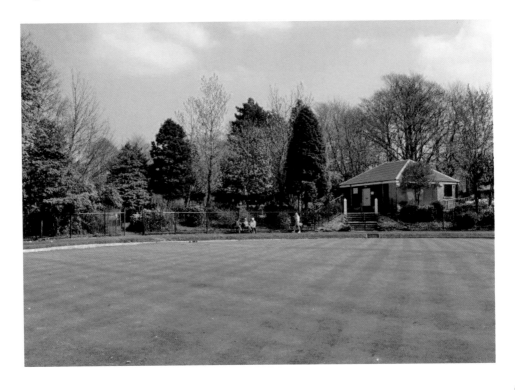

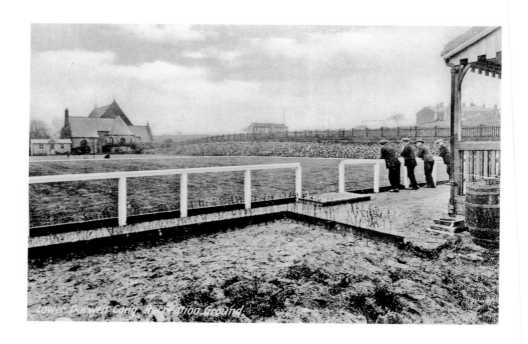

Lower Darwen Congregational Church

Lower Darwen Congregational church and bowling green. The green was laid down and opened in 1928. The recreation ground pavilion can be seen over the distance. The church was built in 1885.

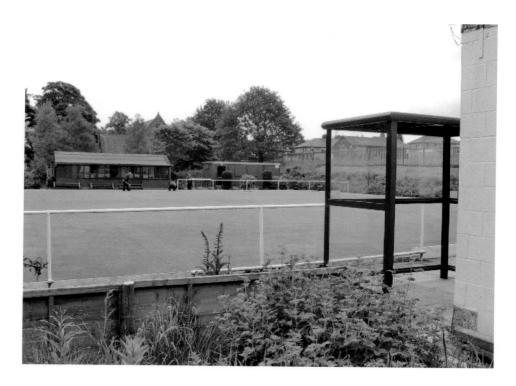

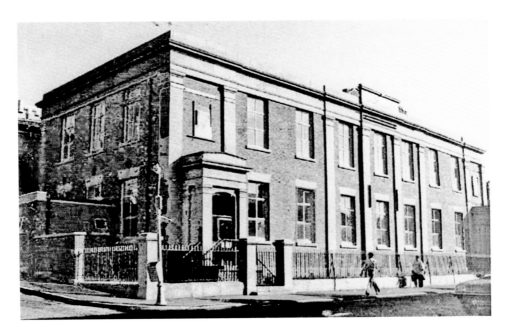

St John's Church of England Primary School

The frontage of St John's Church of England Primary School on Altom Street opened on 8 April 1844 having been built by William Stones at a cost of £2,250. Joseph Feilden laid the foundation stone having being given the land. It opened on Easter Monday 1845 and served the community until it was converted to a mosque in 1978. It has since been demolished and a new mosque built. The infants were on the ground floor and the Juniors were situated upstairs. At the rear were the school yards and beyond them the Parish Rooms accessed from Bicknell Street. It is now a very impressive mosque which is in the process of completion.

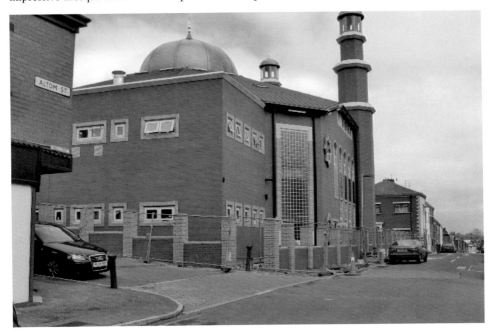

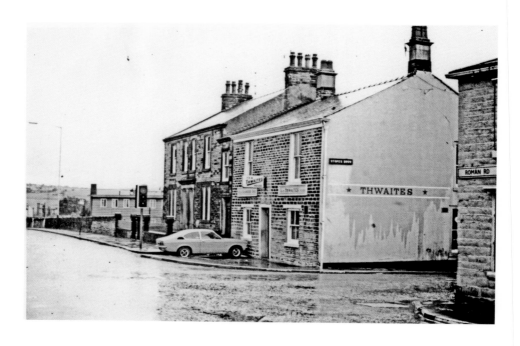

Roman Road and Stopes Brow

Junction of Roman Road and Stopes Brow in 1970s. The Blackamoor Inn formerly the Labour in Vain has recently been renovated. Beyond lies the Royal Ordinance Factory which has now been demolished.

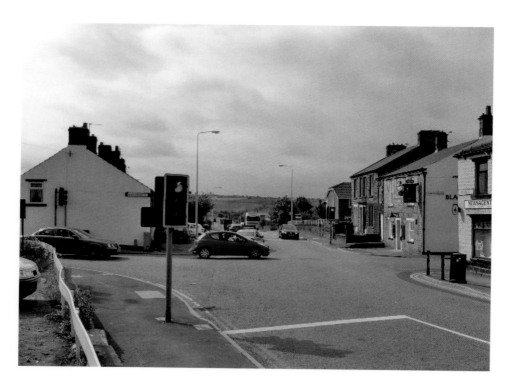

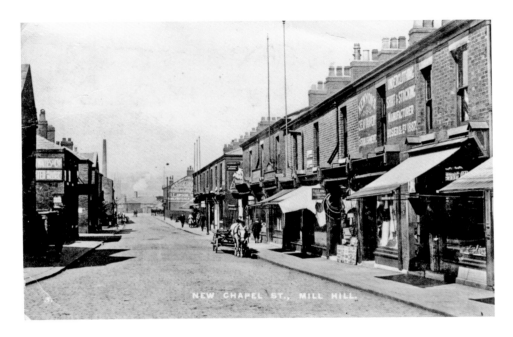

New Chapel Street

New Chapel Street, Mill Hill in around 1910 looking towards the railway station in the distance on the right. A blacksmith's and grocery store could be found in the buildings of Overlockshaw on the left. Lawson's butchers can be identified by the painted sign on the gable end of the shop on the right of the picture in the distance. On the left was Kenyon's drapery shops (est. 1887) and next door can be seen Palings newsagents, selling postcards.

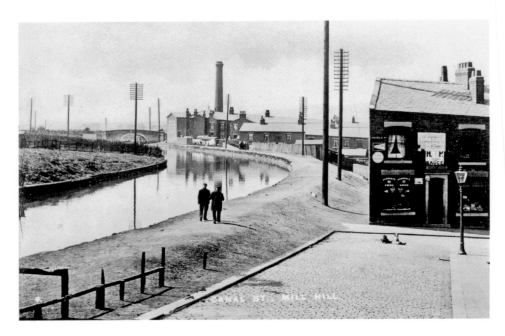

Canal Street

A lovely view of Canal Street, Mill Hill around 1910 with the Leeds and Liverpool canal which, after many years, was completed in 1816. On the right of the picture a gentleman leans patiently against the wall of the Navigation Inn, possibly waiting for opening time. The adjacent shop is on Angela Street and in later years would be converted to a house. Take note of the abundance of telegraph poles following the line of the canal.

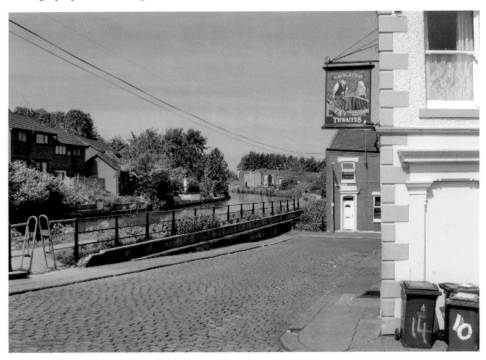

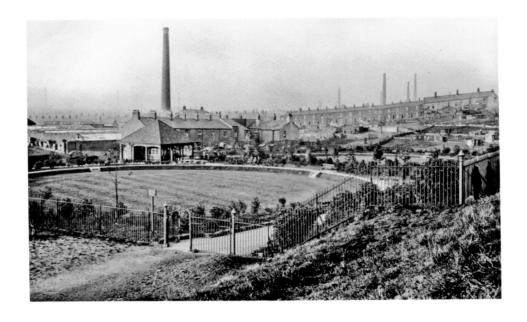

Green Park

Green Park in Mill Hill occupies an area of five acres containing a children's playground and four bowling greens. Here we see the first two greens having been completed in the early 1920s. The canal is out of view to the right.

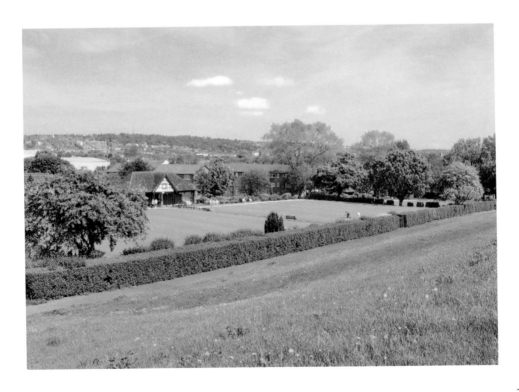

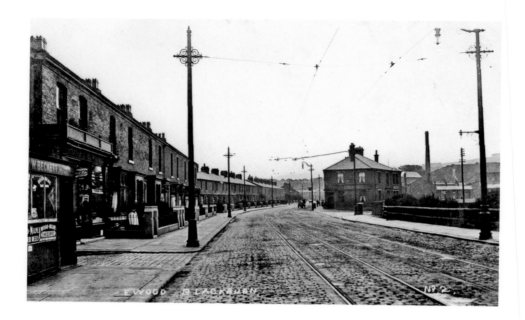

Bolton Road

Bolton Road, Ewood from the Empire Electric Cinema in the 1920s. Neither Beckett's the shoemaker nor Allsup the drug stores would benefit much from the crowds going to Ewood Park on a Saturday. The Albion Hotel (landlord F. Spink) on the other hand would. It has stood there from as early as 1870 and was a Duttons tied house.

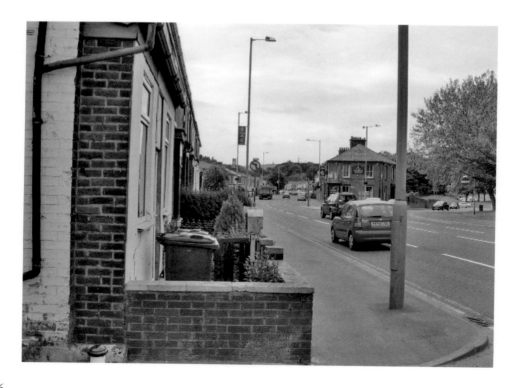

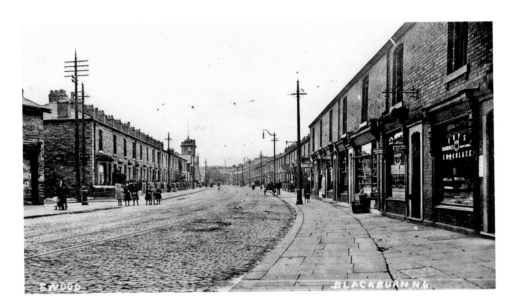

Bolton Road

Another photograph taken on the Bolton Road, Ewood, from further along the road. This was, again, taken in the 1920s and shows, on the left, the Livesey branch of the Co-op on the corner of Tweed Street. The other shops are, from the right, Mannings the grocers, Woollers the cloggers, Houghtons the fruiterers, Mannings the fried fish dealer, and Pomfrets the coal dealer. Seen in the distance is St Bartholomews's church, which has recently been demolished. It was built at a cost of £7,000 and consecrated on 12 December 1910. The tower, known as the Lund Memorial Tower, was the gift of Miss M. A. Lund, and built in 1912.

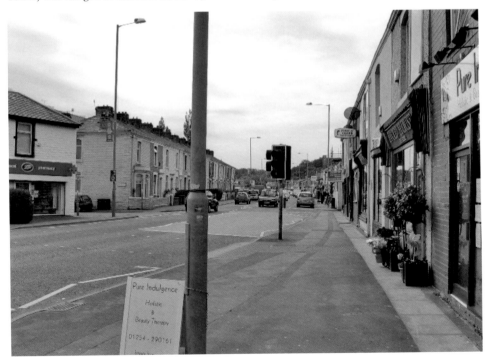

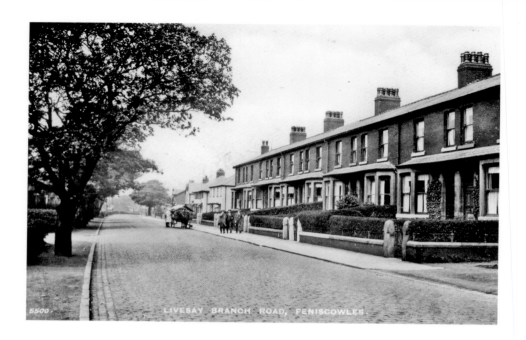

Livesey Branch Road

A view from between the wars of Livesey Branch Road taken by the Preston photographer A. J. Evan's. A lovely view of a horse-drawn street vendor's cart. Notice also the cobbled road surface rather than the tarmac used today.

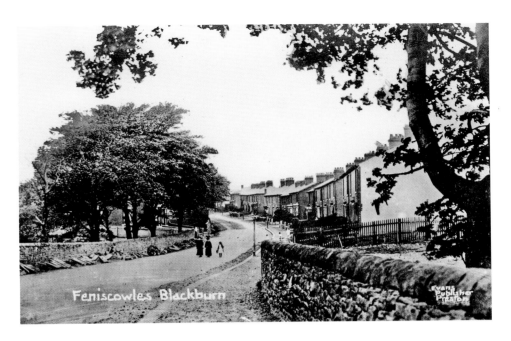

Preston Old Road

Preston Old Road at Feniscowles in about 1910. It was and still is the main thoroughfare to Preston via Hoghton and Walton le Dale. The three figures in the centre of the picture obviously didn't expect any traffic. The road goes through Pleasington and Moulding Water where there used to be an isolation hospital for Blackburn inhabitants. One wonders how effective the lamps where considering the distance between them!

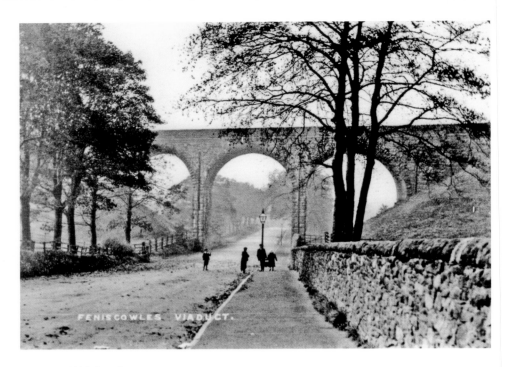

Preston Old Road

Looking along Preston Old Road, Feniscowles, in the opposite direction than the previous page showing the viaduct which carried the branch railway line of the Lancashire and Yorkshire railway through Withnell to Chorley. It was built for coal suppliers in Wigan who required coal to be shipped to east Lancashire rather than by canal. This was authorised by an Act of Parliament in 1864 and work commenced allowing the line to open on 1 November 1869. The viaduct remains despite the lines being lifted many years ago.

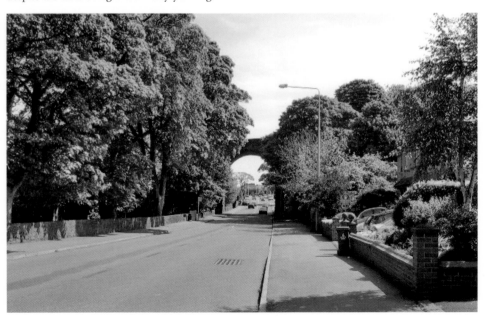

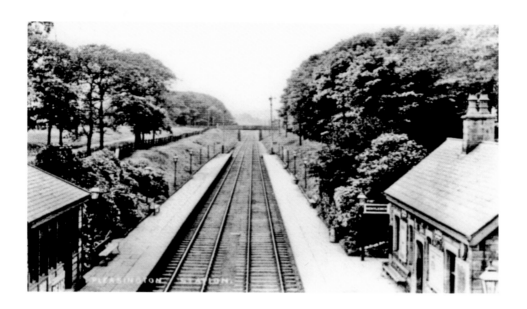

Pleasington Station

Pleasington Station looking from the bridge towards Preston in 1908. It is one of the stations that escaped Beeching's cuts in the 1960s and was better lit than the main roads. Did it really need such a long platform for the numbers of commuters? The line from Blackburn to Preston was opened on Whit Monday 1846. The railway was one of the reasons Pleasington Golf Course was built where it is. The original station buildings have long since been demolished.

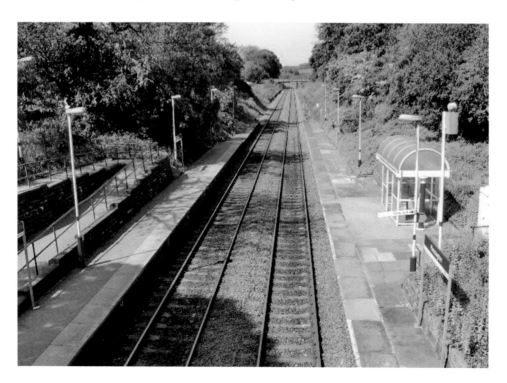

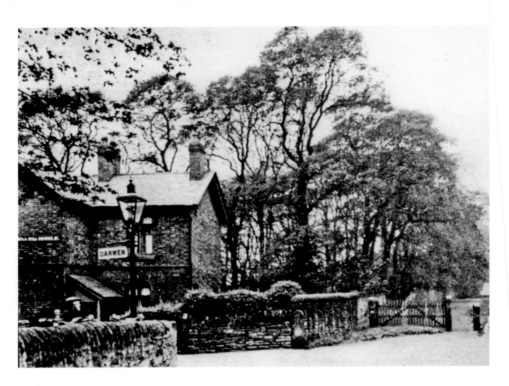

Spring Lane
Spring Lane, Witton, with Mill Hill on Bridge Street on the left. It existed before 1878 and was connected to Preston Old Road when Stancliffe Street was developed and opened on Wednesday 19 October 1938 by the then mayor Alderman James Fryars JP.

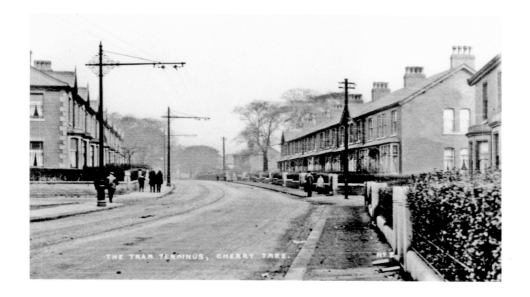

Cherry Tree Tram Terminus

The Cherry Tree Tram Terminus with Green Lane just behind the right shoulder of the cameraman. The tramway had been extended from Witton in 1903 and the last tram to run on this route ran on 31 March 1939. An original goods warehouse for the railway, recently restored, is still to be seen.

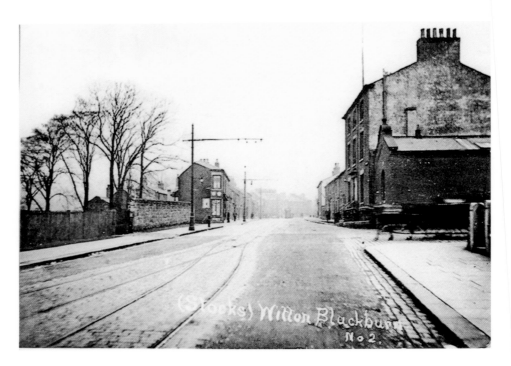

Witton Stocks

A photograph of Witton Stocks before the new Buncer Lane bypass was built. The turning to the left before the first building, is the old Buncer Lane. Spring Lane is on the right with St Mark's Witton Conservative Club beyond which had been in existence from as early as 1881.

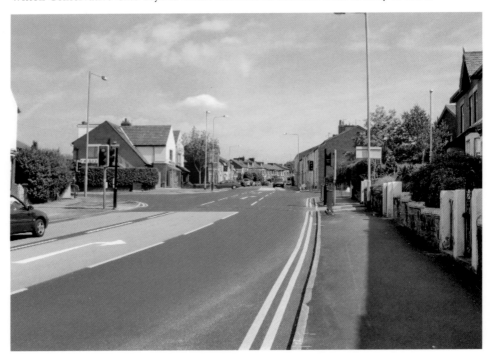

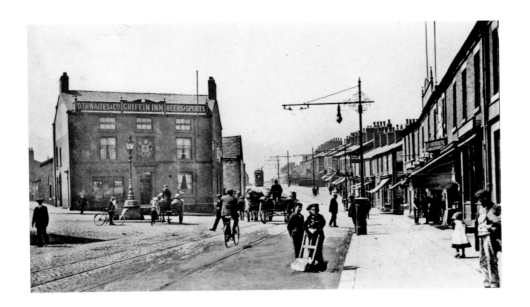

Redlam Brow

A turn of the century photograph of Griffin looking towards Redlam Brow over which a Cherry Tree-bound tramcar is travelling. The Griffin Inn was the Griffin's Head Tavern in 1824 with a bowling green attached. The building with the headboard on the right was the Boundary Arms public house so named as this was the point of the parliamentary boundary and there had once been a toll-bar in operation.

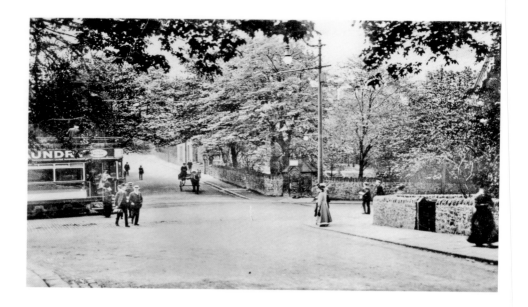

The Preston New Road Tram Terminus

The Preston New Road Tram Terminus at Billinge in 1915. Facing the camera is Revidge Road, built by John McAdam in 1826. A toll-bar operated here on the new road to Preston until it was replaced by the better known Shackerley Toll-Bar further on at the junction of the arterial road at Yew Tree. The rustic cabin beyond the lamp post had been moved from its previous site on the opposite corner.

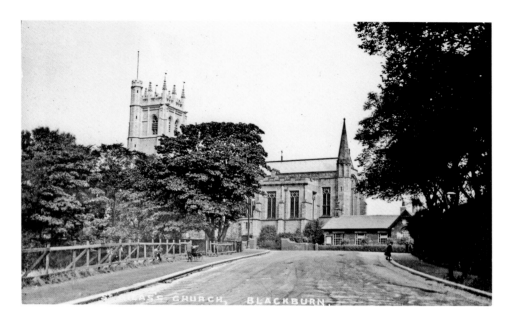

St Silas' Church

A lovely photograph showing St Silas' church and the parish rooms at the top of Buncer Lane. The church was designed by Paley and Austin of Lancaster and opened on Ascension Day 9 May 1898. The tower shown here was not added until 1913. The parish rooms formerly the Billinge Sunday School, had been used for divine service from 1846 until the church was built. The tower never had any bells until Holy Trinity church was closed and its bells were installed at St Silas'.

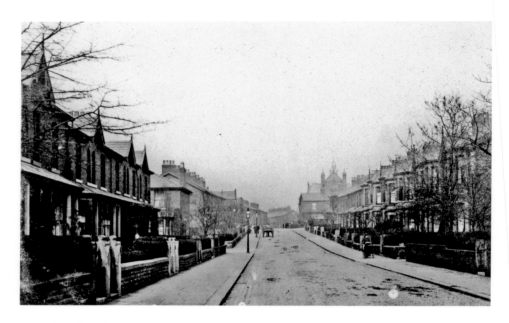

Granville Road

A Shaw photo of Granville Road off Preston New Road in 1919. Plenty of manure for the roses! There is again a distinct lack of street lighting. In the background can be seen Leamington Road Baptist church which opened 2 May 1895. It was designed by Briggs & Wolstenholme of Blackburn and is of red brick and terracotta. Below is a view of Limefield, Preston New Road in the 1920s. The position of the car in the centre of the road is intriguing. Beyond the car on the right is Saunders' Road.

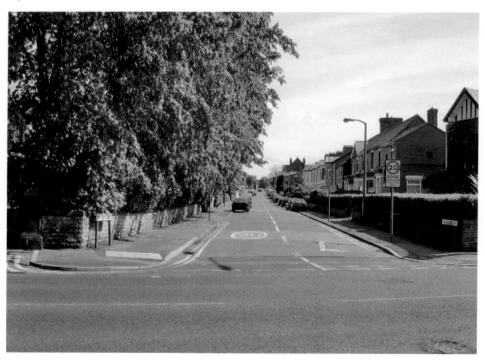

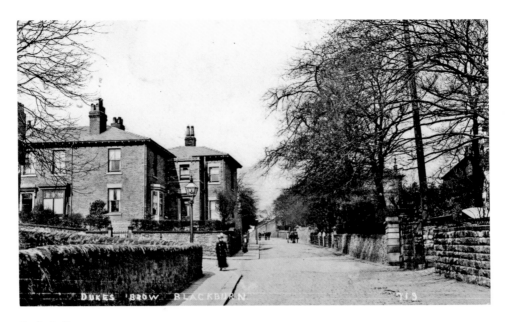

Duke's Brow

Duke's Brow off Preston New Road, showing Adelaide Terrace to the left, in 1907. Springfield Villas are up the cobbled lane to the right and the buildings facing left are Rose Bank. On Adelaide Terrace is one of the oldest houses in Blackburn known as Old Bank House. Royalist troops were posted here in 1642. It is believed that Duke's Brow acquired its name from the farmer at Higher Bank nicknamed 'Duke of the Banke'.

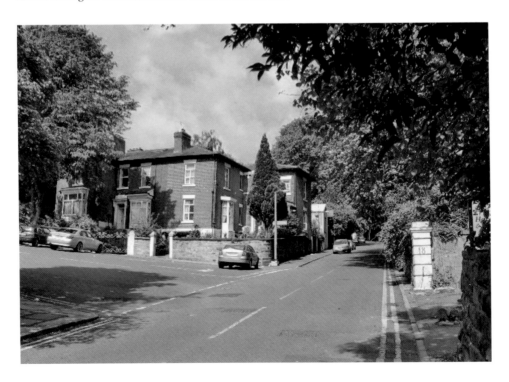

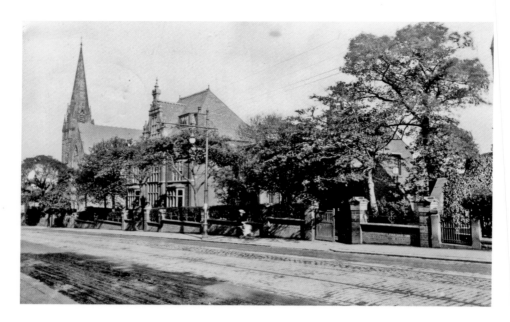

Preston New Road

Preston New Road in 1907 showing the girls' high school and St George's Presbyterian church behind on the corner of Montague Street. This church was erected in 1865-6 at a cost of £9,000. The girls' high school was formed from the public higher grade school in the cathedral grounds. In 1903 the Blackburn School Board was abolished and on 16 March 1903 the town council formed the first education committee. In 1968 it merged with Witton Park Secondary School on Buncer Lane becoming Witton Park High. The building was used by the Lancashire Education Authority for Higher Education until the turn of this century when it was declared unsafe and demolished and the present-day block of flats built there.

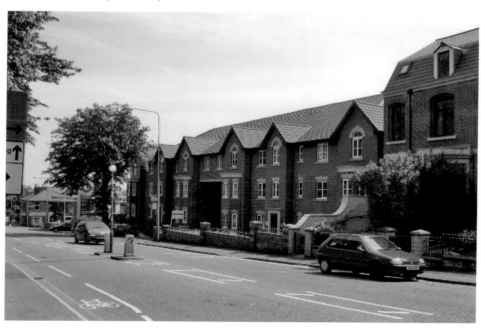

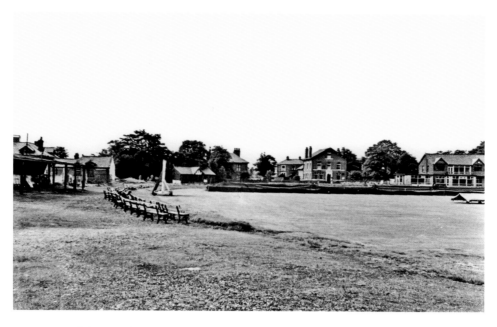

East Lancashire Cricket Club

The home of the East Lancashire Club on Duke's Brow showing the cricket ground with nets for tennis in front of the pavilion. In the centre of the picture is the Alexandra Hotel. This photo was taken before the squash courts were built. The club was founded by the officers of the East Lancashire Regiment and initially Blackburn Rovers played here including a flood-lit match. To the left is the grammar school. In the 1950s and 1960s the best cricketers in the world played here in the Lancashire League.

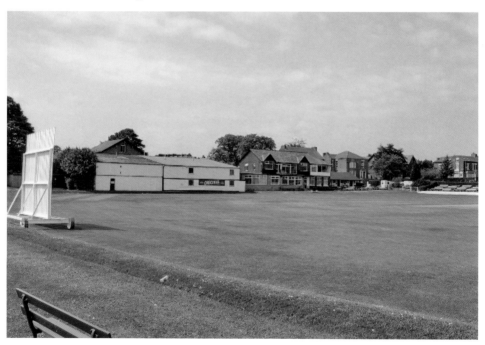

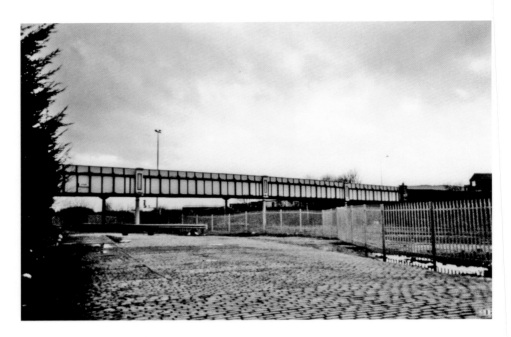

Freckleton Street Bridge

Freckleton Street Bridge, better known as the Iron Bridge led from King Street to Bolton Road and was one-way only, requiring traffic travelling the other way no choice but to travel under Darwen Street Bridge. An Edwardian bridge over the railway, it was probably built by a local firm as Darwen Street Bridge was. The new replacement bridge, called Wainwright Bridge, cost £10 million and was opened in 2008.

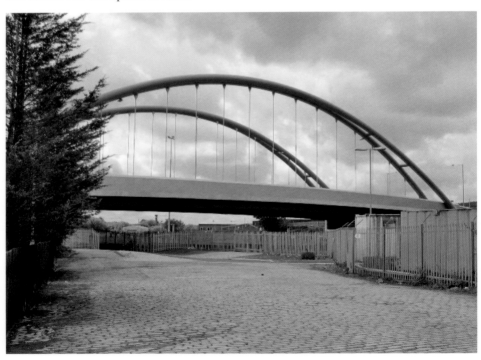

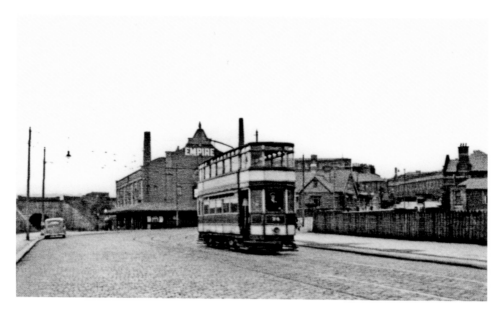

Empire Cinema and the Aqueduct Bridge

Once more we meet up with tram No. 74 *en route* for the boundary at Darwen passing the Empire Cinema and the Aqueduct Bridge just visible to the left of the scene this carries the Leeds and Liverpool Canal on its meanderings through Blackburn. In the middle of the picture behind the tram is the Ewood and Hollin Bank Conservative Club built in 1894 and opened by Mr W. Coddington. Across the road and at the extreme right of the photo is the New Aqueduct public house named after the bridge rewidening scheme of 1925 when it was rebuilt on its present site.

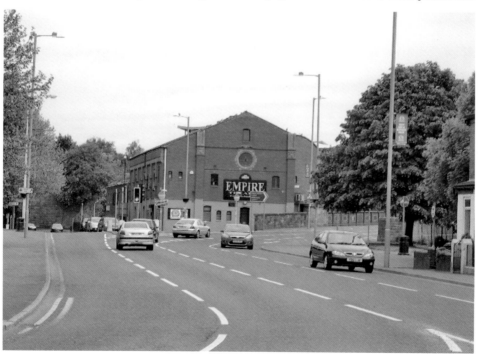

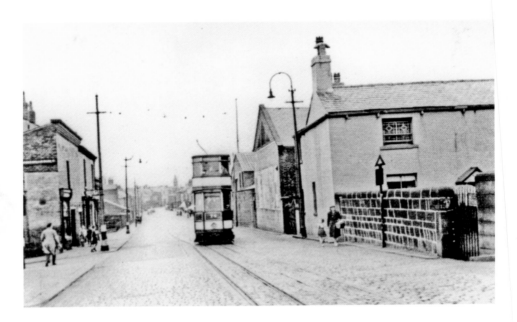

Infirmary Canal Bridge

Infirmary Canal Bridge in a post-war view looking towards town as the No. 74 tram proceeds toward the camera on its way to the Darwen boundary. The tram tracks over the bridge almost merged together so that only one tram at a time could be on the bridge due to weight restrictions, in tramway terms these were known as interlaced track. To the left can be seen possibly the longest street name sign in Blackburn namely Lower Hollin Bank Street. To the right over the stone wall, are the Infirmary Locks of the Leeds and liverpool Canal and the lock keepers's cottage.

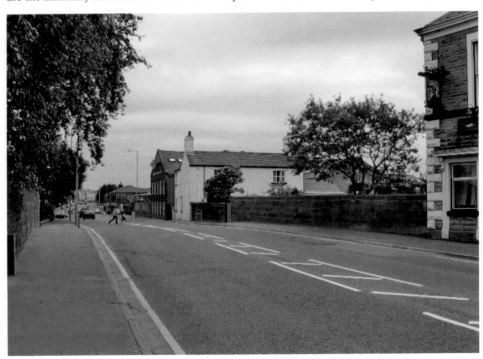

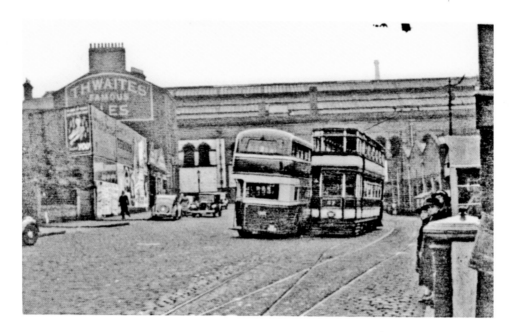

Church and Intack Sidings

In this mid-1940s view we see the station complex to the rear and the Star and Garter public house to the left. In front left are the premises of Syd Smith who owned a taxi and funeral business. He was a well-known figure round the town and always wore a bowler hat. The bus and tram are parked up prior to peak times when they would be put into service. The tram tracks were known as the Church and Intack Sidings.

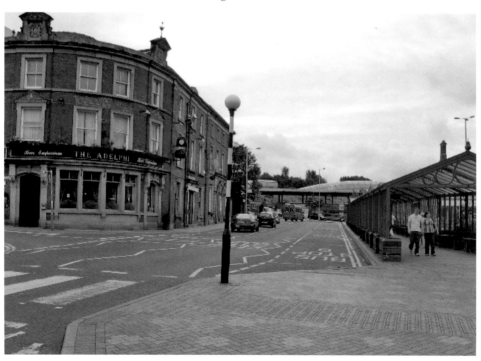

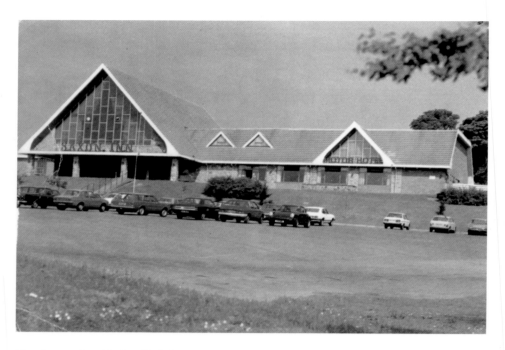

The Saxon Inn Motor Hotel

The Saxon Inn Motor Hotel was built and opened in 1976 to provide visitors to Blackburn with a quality venue when here on holiday or business. The name was changed to the Queen's Moat House and in 1997 to the Blackburn County Hotel. A devastating fire occurred, but after refurbishment it was closed in October 2001 and demolished for housing a few years later.